THE
Archive Photographs
SERIES

AROUND
KENFIG HILL
AND PYLE

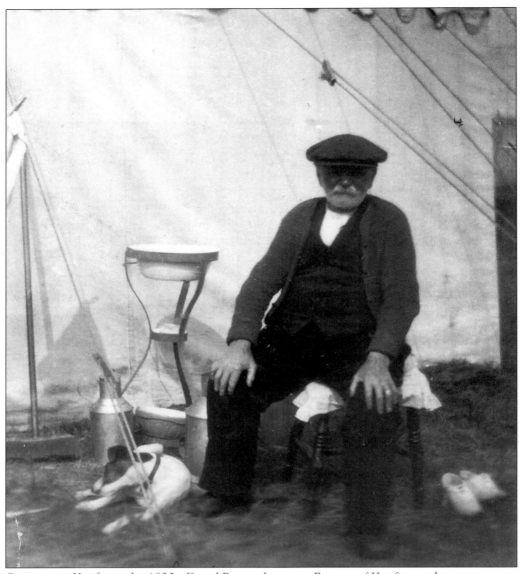

Camping at Kenfig in the 1920s. David Rees, who was a Burgess of Kenfig, used to camp every year with his family on the sand dunes at Kenfig. The camping season lasted throughout the month of August and extended sometimes into September. Note the wash-stand and water-jack outside the tent; a ready supply of fresh water was always available from the wells dug by the campers. The outside life must have done him good, for when David Rees died on 28 August 1944 he was 97 years old. The grand-father of Mrs Janet Davies (Kenfig Hill) and uncle of Dan Rees (Kenfig), David Rees was one of the old Margam Volunteers (the 1st Corps of the Glamorgan Volunteer Rifles), under the command of the Hon. C.R.M. Talbot MP, and he was on parade when the Prince and Princess of Wales (afterwards King Edward VII and Queen Alexandra) visited Margam Castle on 17 October 1881. He was the holder of the Volunteer Long Service Medal and a member of the famous Margam Bando Boys (see p. 128).

THE
Archive Photographs
SERIES

AROUND
KENFIG HILL
AND PYLE

Compiled by
Keith E. Morgan

TEMPUS

First published 1995
Copyright © Keith E. Morgan, 1995

The Chalford Publishing Company
St Mary's Mill, Chalford,
Stroud, Gloucestershire, GL6 8NX

ISBN 0 7524 0314 1

Typesetting and origination by
The Chalford Publishing Company
Printed in Great Britain by
Redwood Books, Trowbridge

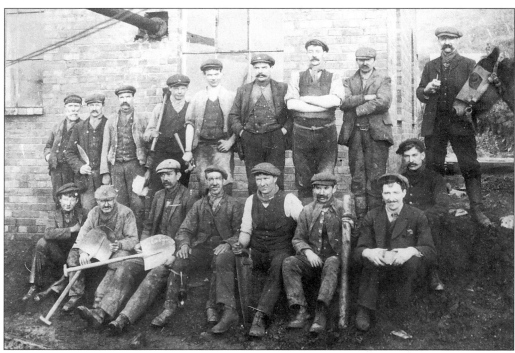

Tytalwyn Colliery miners and workmen, 1912. Back row: James Esaias (third from right). Front row from left to right: Gwilliam James Champion, Thomas Cox, -?-, Esaias John, Ernest Parsons, -?-, Robert Hall.

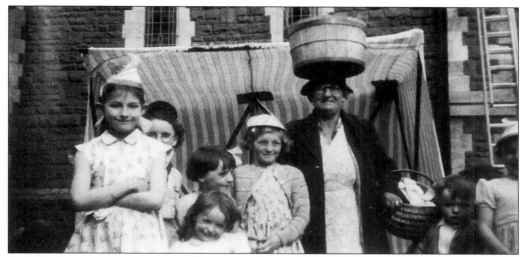

Penclawdd cockle woman at St Theodore's Church, Kenfig Hill, c.1958. From left to right: Gaynor Sinclair, Margaret Jones (back), Heulwen Jones-Davies (front), Delyth Jones-Davies, Sharon Stenner (School Road), cockle woman, Geraint Jones (School Road, son of the Revd Glyn Jones, Moriah Chapel), Mairlis Jones-Davies.

Contents

Acknowledgements 6

Forward by County Councillor Edwin J. Davies CBE JP 7

Introduction 9

1. Historical Background 11

2. Industry 25

3. Commerce and Trade 35

4. Transport 45

5. Religion 53

6. Education 63

7. Organisations 71

8. Views and Scenery 83

9. Events 95

10. The War Years 105

11. Recreation and Sport 115

Acknowledgements

The response that I have had over the years for photographs and information has been tremendous. In acknowledging those individuals and organisations who gave or entrusted me with photographs to make this book a possibility, I would like to sincerely thank Mrs J.B. Bate, Mr Pat Berry, Mr (the late) & Mrs Reg Bradley, Mr Chris Christie, Mrs D. Cooper, Mr & Mrs Ray Cottrell, Mr & Mrs Gerald Davis, Mrs Mary Davis, Mr Colin G. Davies, County Councillor Mr E.J. Davies CBE, JP & Mrs Davies, Mrs Janet Davies, Mr (the late) & Mrs Rennie Davies, Mr & Mrs Teifi Davies, Mrs M. Denley, Mr E. Esaias, Mr A. Leslie Evans, Mr Michael Evans, Mrs S. Evans, Mrs V.I Evans, Mr I. Flower, Miss Gaynor Foster, Mr (the late) & Mrs A.J. Griffiths, the late Mrs Mary Hayball, Mr (the late) & Mrs Trevor Hopkin, Mr & Mrs D.T. Howell, the late Mr Brynmor James, the late Mr V.J.T. James, Mrs Dilys Jenkins, Mr & Mrs Duncan Jenkins, Mrs Llewella Jenkins, Mrs Nan Jenkins, Mr (the late) & Mrs Wyn Jenkins, Miss Cissie John, Mr & Mrs Graham John, Revd (the late) & Mrs David Jones-Davies, the late Mr Bill Jones, Mr & Mrs Dennis Jones, Mr & Mrs Idris Jones, Mrs Margaret (Cound) Jones, Dr Peter Jones, Mrs Sally Jones, Mrs M. Joseph, the late Mrs Emily Langdon, Mrs G. Law, Mr Tony Lewis, Mr (the late) & Mrs Dennis Lugg, Mr Glyn Luke, Mr & Mrs D. T. Marks, Mrs G.A. Marks, Mr Steve Moon, Mrs P. Nelson, Mrs Pauline O'Connell, Mrs Margaret Phillips, the late Mrs Cassie Rees, Mrs Connie Rees, Mr C. Reynolds, Mrs Nancy Roberts, Mrs Blanche Thomas and family, Mr Gareth Thomas, Mr (the late) & Mrs Llew Thomas, the late Miss Gwen Thomas, Mrs Tilly Thomas, Mrs Iris Wall, Mrs Edna M. Watts, Mrs & Mrs Glyndon Williams, Mr (the late) & Mrs Leo Williams, Mrs Margaret Williams, the late Mrs Phyllis Williams, Miss Wilmot, Mrs C. Worth; British Steel plc, Cymdeithas Cynffig – Kenfig Society, Kenfig National Nature Reserve, Mynydd Cynffig Womens' Institute, Ogwr Borough Council Planning Department, Pyle & Kenfig Mothers' Union, St Theodore's Church GFS, the Trustees of the Kenfig Corporation, Y Cefn Gwyrdd. I regret if I have inadvertently omitted anyone from this long list; it has not been intentional.

I would also like to express my gratitude to the ladies of the local libraries for their help and to Mr Simon Eckley, my editor, for both his advice and guidance. Last, but not least, I would like to thank my wife, Malvina for her patience, moral support and for proof reading and checking the contents of the book.

Foreword

By County Councillor Edwin J. Davies, CBE, JP, Chairman of Kenfig Corporation Trustees and President of Cymdeithas Cynffig – Kenfig Society

It affords me great pleasure to have been asked to produce a foreward to this publication, which I believe will be of great interest and value to the people of our time and the generations who follow.

Firstly, I must congratulate Keith on having conceived the idea to produce a book of this nature which I feel will fulfil a need by linking, in a most attractive form, past ways of life with the rich industrial and archaeological history of the area. This is the first book of its kind to cover the locality but the photographs and outstanding literary content will make it easy for the reader to assimilate. Keith and Malvina have 'done this together' and I truly believe that as a community we are greatly indebted to them, not only for this current production, but for the research and photographic expertise that has previously resulted in exhibitions, slide shows and lectures on numerous subjects, thus bringing to life much of the illustrious history of our area. Behind the production of this book lie many patient years of collating information and I am sure that Keith will support me in thanking the many individuals and organisations who have contributed in a variety of ways. Many old photographs, articles and the like, which have gathered the dust of time in disused attics and draws, have been brought back to life for all to see and enjoy. Keith is making a valuable contribution to society by preserving and publishing this historical record and I trust that he will continue his good work for many years to come.

This area is unique in many ways. It has remains from antiquity at Water Street, Pen Castell and Stormy Down, old and revered churches at Mawdlam and Pyle, and medieval buildings at Sker, Ty Maen and Llanfihangel. Its rich industrial past gave birth to a thriving community at Kenfig Hill and left us with a fine and well preserved example of an early blast furnace at Cefn Cribwr. The ancient Borough of Kenfig has one of the oldest forms of local government in the country as it is administered by the Trustees of the Kenfig Corporation. This is a successor body to the Burgesses of Kenfig whose origin dates back to the eleventh century and their creation by the Lord of Kenfig Castle soon after the Norman invasion of South Wales. The present Trustees enjoy virtually the same ancient rights as their predecessors, although at one time, their future was seriously in doubt.

It had been assumed for many years that the Freeholders of the Common were the Margam Estate who had acted in every way as the rightful owners in that they had received rents and benefited from the sale of land. The issue of ownership came to a head in the late 1950s when the Steel Company of Wales laid a 10" pipe line from Kenfig Pool to the river Kenfig with the intention of pumping water to supply their plant in Port Talbot in the event of a drought. On completion of the scheme, the Margam Estate forwarded a letter to the Trustees confirming ownership of the Common and Kenfig Pool. The allegation relating to ownership was immediately challenged by the Trustees with the result that each trustee was issued with a High Court writ. The case came before the High Court in London in May 1970 and was concluded the following month. The judge (Mr Justice Goulden) after due consideration decided in favour of the Trustees, thus vesting in their hands the 1,600 acres that comprise Kenfig Common and the Pool. This was indeed a momentous decision as it meant that Kenfig now belonged to the people in perpetuity.

During the ensuing years, the unique scientific value of Kenfig has become widely recognised

and resulted in the setting up of the Kenfig Nature Reserve. Kenfig is also acknowledged by the European Commission as an area of outstanding natural beauty and the area has now been accorded National Nature Reserve status.

A photograph included in this book shows the remains of Kenfig Castle, reminding us of past generations of people who resided in Kenfig when it was a very busy market town, noted for its trading and contribution to the economy of the area. The history of Kenfig is tempestuous as it was continually subjected to raids from both sea and land. However, these raiders were secondary to Kenfig's worst enemy – the sand – which was far more silent and effective. Over a period of some two hundred years, the town was gradually engulfed by the sand to such an extent that by the year 1602 nothing remained save for a few groins of the ancient castle which thrust themselves up through the sand as if in defiance of nature. Kenfig is probably the only medieval town which remains in its original condition. Virtually undisturbed, it contains a church, school and hospital. I believe that if ever the searching trowels of the archaeologists investigate the old town, then a great deal will be learnt about life in the medieval period.

The area has fascinated historians with the result that in 1989 the Kenfig Historical Society (Cymdeithas Cynffig) was formed, since which time it has been extremely active and grown from strength to strength. Keith has edited the society's newsletter since its inception; his contribution over the past years has been invaluable as he has unstintingly projected the society's image in the media and in every other way possible. There can be no doubt that his dedication has been a major factor in the ongoing success of the organisation.

Finally, allow me to commend this book of outstanding quality and interest to every reader. I feel sure that it will be appreciated not only by those who love our area, its history and heritage, but by historians everywhere.

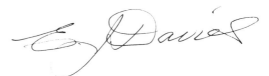

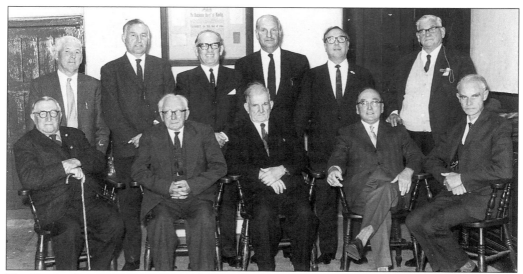

The Kenfig Corporation Trustees who successfully contested the ownership of Kenfig Common and Pool, June 1971. From left to right, back row: Evan H. David; Howard Overfield; Graham Harries; Elwyn Davies; Mostyn Jones MBE, DL; Fred Jones. Front Row: William John; John Thomas; Lewis Jones MBE; Edwin J. Davies CBE, JP; E.D. Hennys Plumley MBE.

Introduction

By Keith Morgan

For many years, I have enjoyed the hobby of recording on film the changes that are taking place around us every day. Often these go by unobserved and unrecorded. When the changes are eventually noticed, it is often too late. Familiar landmarks such as bridges, shops, even red telephone kiosks, are there one day and gone the next. Once my enthusiasm was raised, however, my interest expanded into capturing photographically the various events that were also taking place. In the roll of photographer, I realised that I was becoming an historian for the future and became determined to fully satisfy this commitment. To do so, I felt there was a need to record past changes before they were lost or forgotten. I further extended my objective to the copying of old photographs which were kindly loaned or given to me by local residents and organisations.

My collection of photographs grew and grew and I wanted others to also have the benefit of seeing and enjoying them. As a result, my wife Malvina and I have presented many slide shows and photographic displays. These have given pleasure to many and aroused considerable interest in, and enthusiasm for, the history of the locality. Consequently, more and more old photographs have been made available and the collection continues to grow to this day.

The selection of prints contained in this publication covers the changing styles of life in the community around Kenfig Hill and Pyle, which also embraces Cefn Cribwr to the east and Stormy, Cornelly, Sker, Kenfig and Mawdlam to the south. The area has seen many changes over the past centuries. Kenfig, a once prosperous town, was abandoned in the fifteenth century when it was engulfed by sand leaving only the castle as evidence of its former location. This event has been vividly recaptured in Thomas Gray's book, *The Buried City of Kenfig* and in R.D. Blackmore's novel, *The Maid of Sker*. The inhabitants of the town gradually dispersed throughout the adjoining villages of Mawdlam, Cornelly and Cefn Cribwr; the old church of Kenfig was dismantled and re-erected at Pyle and a new town hall built overlooking the site of the buried town. What was once a disaster area, is now a national nature reserve covering some 1,600 acres. Thanks to the determination and resolve of the Trustees of the Kenfig Corporation, the whole area embracing Kenfig Common and Pool was won for the people for all time following the successful outcome of the famous court case of 1971. Next year, 1996, sees the 25th anniversary of this momentous event.

Basically a farming community, the region remained so until the advent of the Industrial Revolution. Then the demand for iron and coal began to dramatically alter the appearance of the area. The start of these changes was heralded by the building of an early blast furnace and ironmaking complex at Cefn Cribwr. This set the stage for the construction of several larger, more commercial ironworks and the sinking of many coal mines. The area soon burst into life. What was once farmland now became Kenfig Hill, a thriving and fast-growing community that soon spilled over into the adjoining villages. The expanding industry itself spawned dependent trades and commerce flourished as a result. Houses and shops were built for the ever expanding immigrant population. Roads and railtracks spread throughout the region to meet the ever

increasing requirements for better and faster means of transportation. The building of schools, churches and chapels followed close behind to satisfy the respective educational and spiritual needs of the inhabitants.

These photographs and illustrations chart the fortunes of the region from very early times, through the growth and decline of industry, right up to the fairly recent past when the whole area became mainly residential.

I am grateful to the Chalford Publishing Company Limited for having provided me with the opportunity to present this book. As Editor of Cymdeithas Cynffig – the Kenfig Society, I also appreciate the support that this organisation has given me in this venture. It brings to fruition many years of work in collecting photographs and provides a convenient format for recording and preserving them as a heritage for the future. I would also like to think of the book as a tribute to all those enthusiastic people who have loaned or given me old photographs. Many of these images come from private collections and have not been published before. I know that the book will bring memories of the past flooding back and give pleasure to all who acquire a copy. Also, I trust that it will serve as an encouragement to others to come forward with photographs for future publications.

S. Harris, the Cash Ironmonger and Cycle Agent, on the corner of Bridge Street, Kenfig Hill, 1930s. Mr S. Harris is standing in the shop doorway with a young Eddie John to his right. Times have not changed much; credit was also available in those days. As can be seen from the advert on the shop window, cycles could be acquired on the hire purchase system with 'no deposit' at two shillings weekly.

One
Historical Background

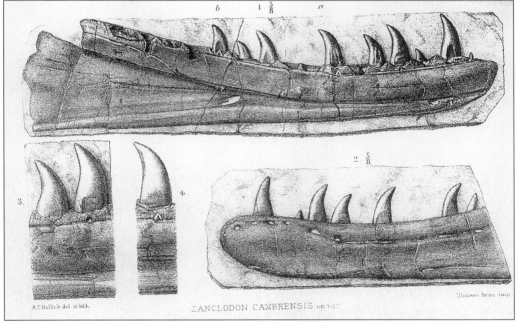

b 1.⅝ a

2.⅝

3.

4.

A.T.Hollick del. et lith. ZANCLODON CAMBRENSIS sp. n.r. Mintern Bros. imp.

A 'dragon' lived at Stormy Down. The first inhabitants of Kenfig Hill, Pyle and the surrounding district were very different to those who occupy the area today. The above sketch has been reproduced from the *Quarterly Journal of the Geological Society of London* (1899) and illustrates the fossilised remains of a flesh-eating dinosaur that once roamed the landscape we now call Stormy Down. The remains of such a dragon were found in 1898 and consisted of the fossilised impressions of its lower jawbone with several teeth in place. The jaw is typical of *Zanclodon*, a strongly built, two-legged reptile with a large head and short arms that stood upright balanced by a long, stiff tail. Appropriately named *Zanclodon Cambrensis*, it belongs to the late Triassic Period and was the first of its species to be recorded in Wales. The actual remains are on display in the National Museum of Wales, Cardiff.

The appearance of the region has changed greatly since the days of the dinosaur. Then Wales was an area of high land surrounded by low desert plains with a hot, dry climate. Since the demise of the dinosaur over 65 million years ago, there have been a number of periods of glaciation which themselves have been interlaced with periods of forestation followed by submersion of the land by the sea. These have helped shape the landscape and outline of the coast that we see today. The subterranean riches of the area are far more ancient in origin dating back to the Carboniferous period (370-280 million years ago) during which the measures of the South Wales coalfields and beds of carboniferous (coal-bearing) limestone were laid down. The coal seams are contained in the limestone as if the latter were a basin. The southern extremity or rim of the basin is defined by the ridge of Cefn Cribwr. This is formed of millstone grit which sits on top of the limestone and rises majestically to an average height of 420 feet above sea level at its crest. Lying parallel to it, but at a slightly lower level, is an equally impressive ridge where the limestone outcrops to the surface – that of Stormy Down. The geology and geography of the region have been largely responsible for influencing the distribution of the population, as well as the growth, development and prosperity of the district. Indications show that man had settled permanently in the area by the Neolithic Period (4500 – 2500 BC). At that time, he could have probably walked on dry land on what is now the Bristol Channel. Early man left his mark in many ways from graves, stone axes, flint chippings, shards and brooches to standing stones like the menhir (pictured above) in a field between the M4 Motorway and Ty'n Seler Farm, Water Street, Kenfig.

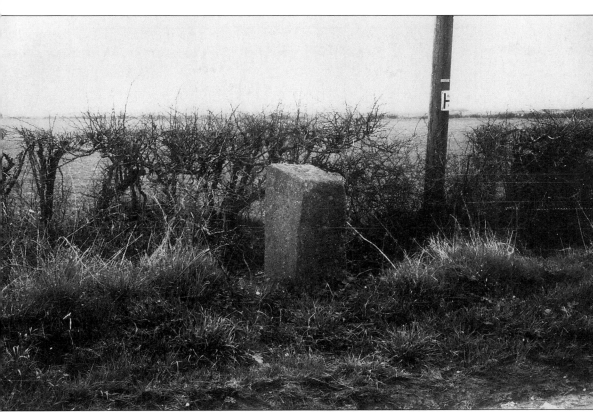

Habitation started as isolated homesteads with a settlement at Kenfig both before and during Roman times. A number of coins and tile fragments have been found in the area to confirm the latter. This settlement must have been busy during the Roman era as it lay very close to the Roman road that traversed from one end of Glamorgan to the other. Constructed during the subjugation of Wales by Julius Frontinus c. AD 75, it runs over Stormy Down to Mawdlam and then on through Water Street to Neath past Port Talbot and Aberavon. There is no actual Roman name for the road, but the Victorians fancifully called it the Via Julia Maritima in honour of its founder, Julius Frontinus. A number of Roman milestones have been found that attest to this route, all of which now reside in museums with none remaining *in situ*. Kenfig itself has a possible claim to being the location of the lost Roman Fort of Bomium. When the Romans finally left the British Isles in AD 440, the period known as the Dark Ages began for which limited historical and archaeological evidence is available. The photograph above, however, shows a replica of a mid-sixth century stone which has been placed in the same location as the original on the grass verge at Water Street. Called the Pumpeius Stone, it bears memorial inscriptions in both Ogham and Latin on its face and was probably positioned above the grave of the man it commemorated. The original is in the Margam Stones Museum.

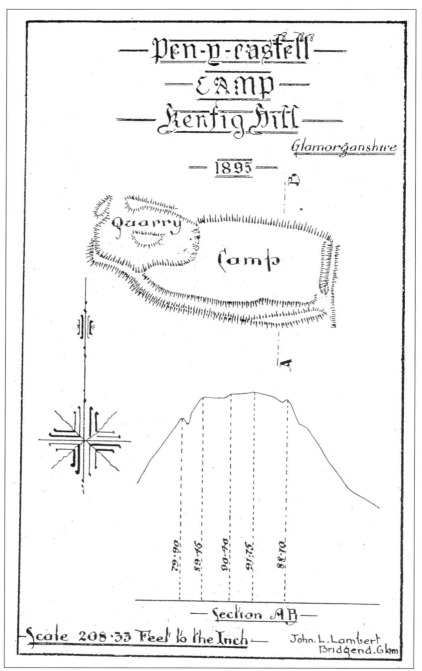

Plan of the seventh century Iron Age camp at Pen-y-Castell, Kenfig Hill, drawn in 1895. This fortification, 700 feet long by 220 feet wide, was strategically positioned on the crest (or ton) to command a military position over the two valleys either side and the approaches from the sea. The remains of the camp were extensively damaged by quarrying in the nineteenth century while those of a ninth century fortification on Stormy Down were completely destroyed by similar, but more recent, commercial undertakings.

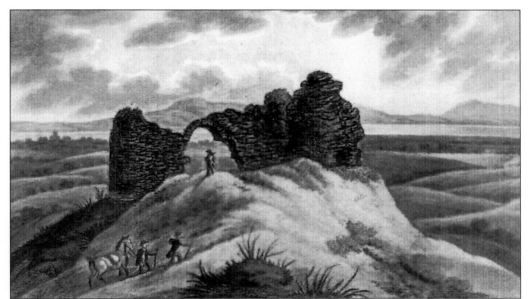

Kenfig Castle, as seen and sketched by Donovan during his visit to South Wales in 1804. The castle was built by the Normans at Kenfig as part of their 'frontier defences' against the Welsh. The first structure is thought to have been erected by Robert Fitzhamon, earl of Gloucester, c.1100. This would have been of timber with the first actual stone castle being built c.1185 following successive attacks by the Welsh. The first church of St James would also have probably been built during the same period. Kenfig, a sizable commercial town and port, was attacked and burnt many times by the Welsh and others. What they failed to destroy, nature did, with the aid of sand, leaving both castle and town overrun and in ruins by 1538.

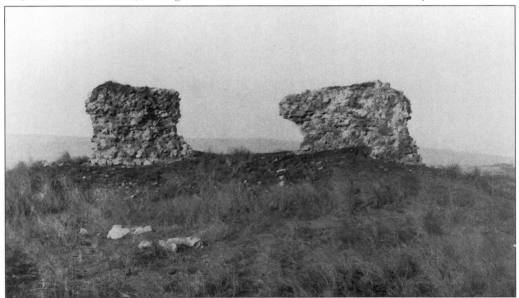

Kenfig Castle in 1909. By this time, much of the structure seen by Donovan had disappeared. The arch had collapsed leaving just two sphinx-like pillars of stone protruding above the ground.

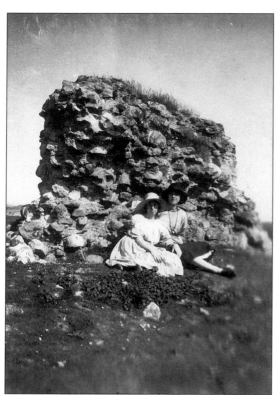

Cassie and Janet Waite visiting Kenfig Castle remains in 1926. This was the year before Arthur Richards of Port Talbot carried out the excavation of the castle.

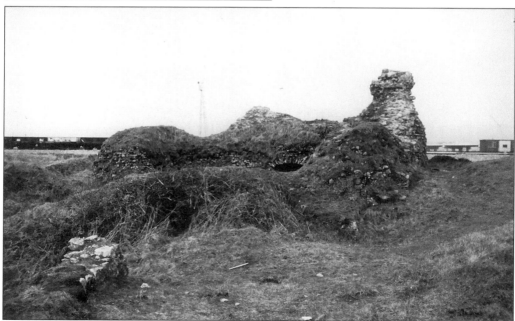

Kenfig Castle in the 1970s. The arched roof of the castle basement or 'dungeon', exposed following the dig of 1927, can just be seen in the centre of the ruins. Over the years, and subsequent to the excavations, one of the pillars has collapsed.

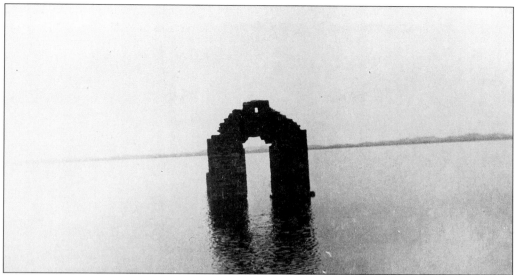

The old boathouse at Kenfig Pool in 1950. This is the largest natural fresh water pool in Glamorgan (South, Mid and West). It covers an area of seventy acres and is a favourite refuge for many different species of wildfowl throughout the year. Today it forms an integral part of the Kenfig National Nature Reserve. There are many fictional stories associated with the pool, none of which are based on historical fact. The old boathouse attests to the use of Kenfig Pool in times gone past.

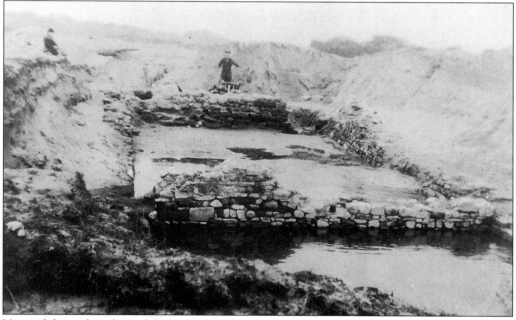

View of the archaeological dig carried out by the Margam and Aberavon Historical Society in the buried town of Kenfig during the early 1930s. Lieutenant J. Jarratt, the excavator in charge of the work, is in the centre of the photograph. The building, exposed as a result of the excavations, was probably the same sixteenth century farmhouse noted by John Leland in his *Itinerary through South Wales* in the 1530s.

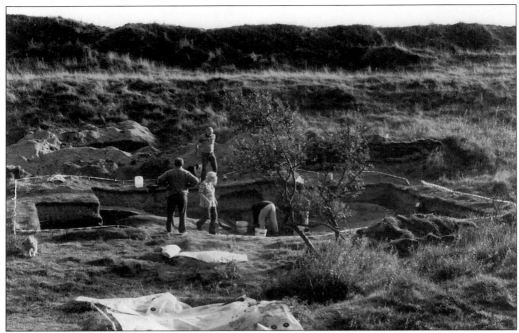

The Kenfig Society archaeological team at Kenfig during the 1993 season. The picture shows a general view of the dig being carried out in the old town of Kenfig, outside the boundary of the castle bailey.

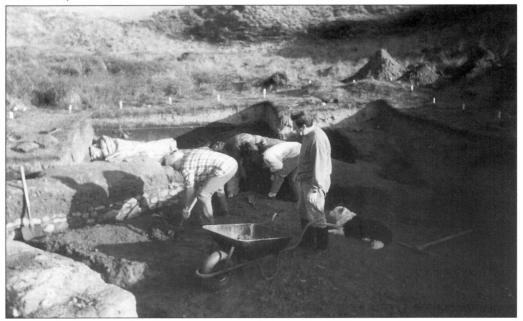

The Kenfig Society archaeological team at work during the 1993 season. The structure exposed by the dig, and to the left in the photograph, was a medieval dwelling house. A great many artefacts ranging from the Roman to late medieval periods were found during the course of the excavations. Successive digs have been carried out each summer since.

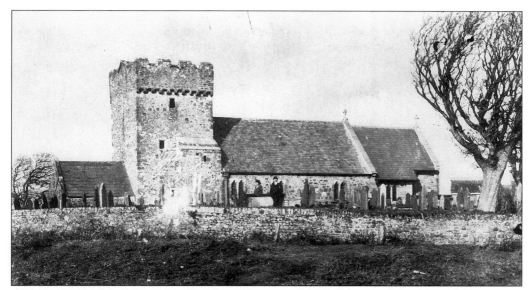

St Mary Magdalen's Church, Mawdlam, from the south, c.1907. The precise date of the erection of the church is uncertain but has tentatively been placed at 1255. The church was built as a chapel-of-ease for the older St James' Church in the town of Kenfig to meet the demands of an expanding community. The fact that the burgesses built it on rising ground, well away from the town, suggests that they were apprehensive even then about the sand problem which threatened to engulf the borough. Subsequent events proved that they showed commendable foresight in their choice.

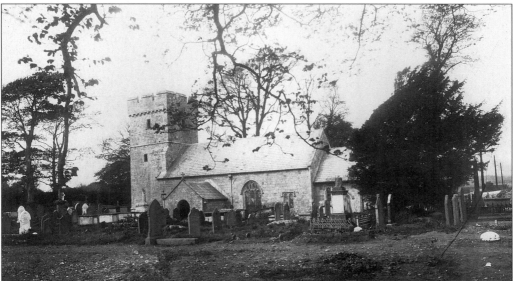

St James' Church, Pyle c.1907. When the sands threatened to engulf Kenfig, it is reputed that the old church of St James in the town was dismantled stone by stone and rebuilt in 'reverse' at its present location. This could well be the case and justify why St James' is called the 'upside-down church'. An observation of the structure shows in some places small stones low down on the building supporting much larger stones above. A carving on a small wooden shield on the north roof timber base beam indicates 1471 as the date for its rebuilding.

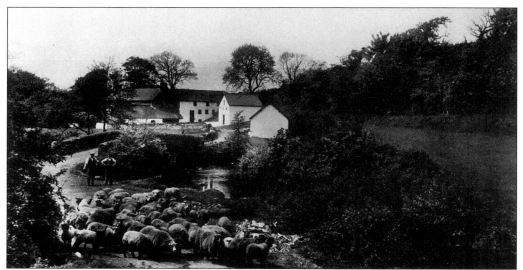

Llanfihangel Mill, Marlas, Pyle, in the 1920s. One of the granges of Margam Abbey, this photograph could well have formed the subject for one of Constable's famous paintings of an idyllic country scene. The mill, which was fed via a sluice or regulator from a dam and waterfall upstream at the Collwyn, was still working in 1926. The remains of the water wheel and associated machinery are still *in situ* today.

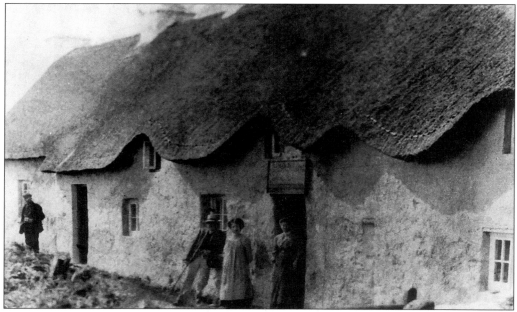

The Angel Inn, Mawdlam, in the 1920s. The lady in the doorway, is the licensee, Mrs Catherine Morgan. She retained the licence for fifty-four years, the fourth in her family in a hundred years to run the inn. Long after her days, the inn was modernised, enlarged and turned back-to-front. The picturesque thatched roof was replaced by slate and a new entrance created on the opposite side of the building. The Angel Inn now faced the outside world rather than the small village of Mawdlam. The building has been dated to the thirteenth century, the same period as St Mary Magdalen's Church alongside.

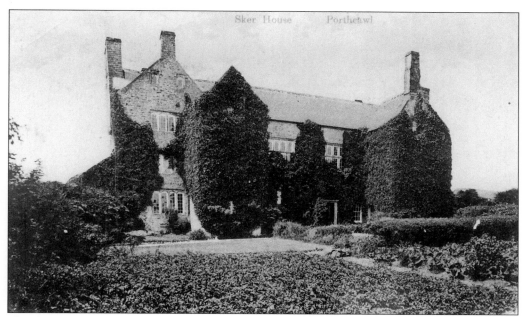

Sker House, *c.*1909. The building was immortalised in R.D. Blackmore's novel, *The Maid of Sker*. Blackmore lived for a time in Nottage and was well acquainted with the area. The house was originally built by the Cistercian monks of Neath Abbey in the fifteenth century when 100 acres of land at the 'Grange of Skerra' were sold to them by the Abbot of Margam. Most of the present-day structure dates from the seventeenth century.

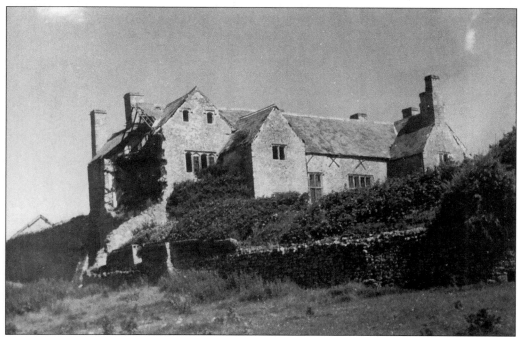

Sker House in the 1960s, showing the general deterioration of the property and the collapsed wing.

The Prince of Wales Inn, Kenfig, c.1910. The inn dates from the sixteenth century when it was built to house 'The Guild Hall' in place of that buried in the medieval town. At one time the building was referred to as Ty Newydd – the New House Tavern. This name was changed to the Prince of Wales some time in the eighteenth century in honour of George, Prince of Wales, who was crowned King George IV in 1820. It is thought that the original building was supported on pillars and arches with the ground floor serving as a general meeting place and market. However, the inn was rebuilt in 1808 and all evidence of the old structure has disappeared.

The Old Guild Hall above the Prince of Wales Inn, Kenfig, c.1910. Note the Kenfig Corporation mace on the table and the safe in the centre of the wall at the back. It was this safe that was opened in December 1943 by Mr Wilson, the projectionist at the Gaiety Cinema, Kenfig Hill, to reveal the lost Kenfig Charters dated 1397, 1420 and 1422. It was in the Old Guild Hall that the burgesses met, held courts and exercised their rights as laid down in the Kenfig Charters. The trustees, the successors of the burgesses, still meet here to discuss Kenfig Corporation business, and a Sunday school has been held here regularly since 1863. The inn is steeped in history and the 'presence' of ghosts has been noted.

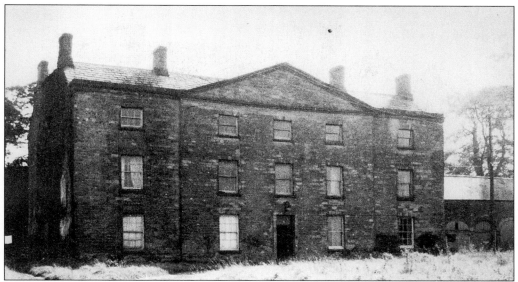

The old Pyle Inn prior to its demolition in 1959. The inn was built in 1782 by Thomas Mansel Talbot, the Squire of Margam. Probably the last coaching inn to be built on the London road, it had twelve double-bedded rooms and a spacious dining room. Up to thirty guests could be accommodated at any one time and the stables housed eight coaching horses. The forty-acre farm attached supplied all the necessary provisions. Lord Nelson and Lady Hamilton are reputed to have dined here on their return journey from Fishguard, while Isambard Kingdom Brunel was a guest during the construction of the South Wales Railway. When it opened in 1850, the railway sounded the death knell of the inn for coaching purposes. The building was to survive as an inn and meeting place until 1886 when it became a private residence. It was then converted into flats and served this purpose until its final demise.

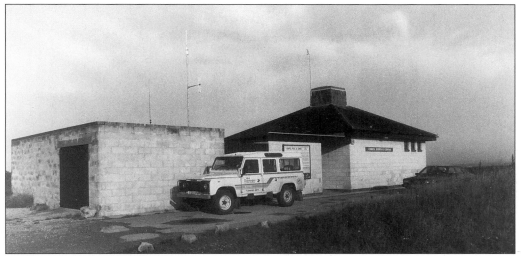

The Kenfig National Nature Reserve centre, officially opened on 20 May 1980. Following the 1971 court case, ownership of the Kenfig Common and Pool was awarded to the Trustees of the Kenfig Corporation. In April 1978, the Kenfig Burrows with Pool, altogether embracing some 1,600 acres, were declared a Nature Reserve. Eleven years later in May 1989, as a site of special scientific interest, this was upgraded to National Nature Reserve status.

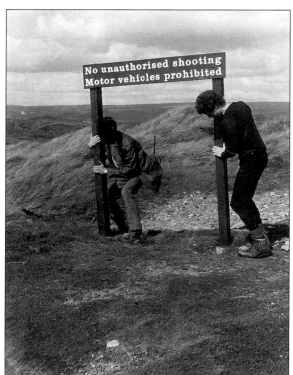

Volunteer warden, Simon Davies and his assistant erecting notices to protect the environment of the Kenfig National Nature Reserve, 1980s.

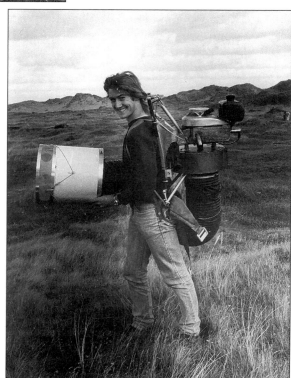

Mr Richard Harris using a specialised 'vacuum cleaner' to collect insect samples on the Kenfig National Nature Reserve, 1980s.

Two

Industry

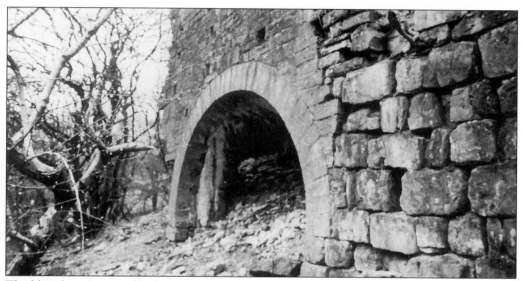

The blast furnace at Bedford's Ironworks, Cefn Cribwr, pictured here in the early 1980s prior to restoration work. The ironworks, the first influence of the Industrial Revolution in the area, was established by John Bedford, an entrepreneur, who originally came from the Midlands. Following his arrival at Cefn Cribwr in the early 1770s, he carried out development of the ironworks over a lengthy period until his death in 1791. Bedford was a great designer and experimenter. While other blast furnaces had been built at the heads of the valleys to take advantage of the ready supply of timber to provide the charcoal needed as a fuel, John Bedford chose to site his ironworks close to the sea and near to the southernmost edge of the South Wales coalfield. His blast furnace was built with the characteristic solidness and splendour of the day and was designed right from the start to be fuelled by coke (i.e. the end product of heating coal in a confined space to drive off the more volatile constituents). Bedford, however, was not a good businessman and the ironworks was never very profitable even during his lifetime. Following his death and thereafter, the concern was only operated for short periods, lying idle in between. Even the opening of the Dyffryn Llynfi & Porthcawl Railway in 1828 could not save the ironworks and it eventually closed for good about 1836 and subsequently fell into decay. Nature did the rest and, as a result, we now have, preserved for all time, a unique and virtually complete example of an early ironworks. Following its acquisition in 1987, Ogwr Borough Council have conducted a very thorough archaeological programme to restore and preserve the site, a scheduled ancient monument, as part of its Bedford Park Heritage development.

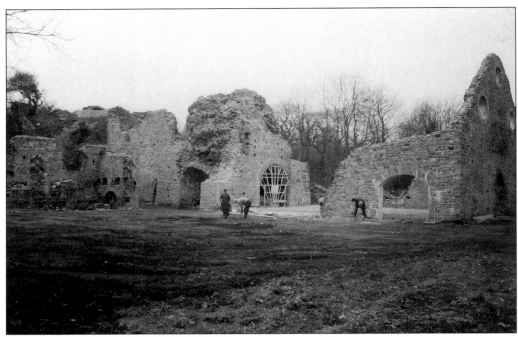

The blast furnace and cast house of Bedford's Ironworks, Cefn Cribwr, following site clearance and restoration work, March 1993.

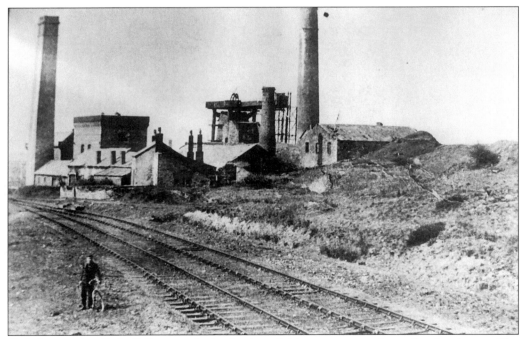

Cefn Ironworks, Cefn Cribwr, at the beginning of this century, not long after its closure. The enterprise was originally known as the 'Pyle Works'.

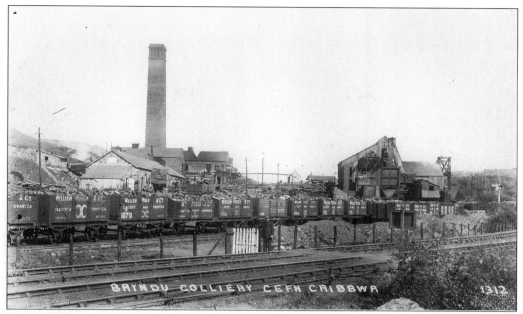

Bryndu Colliery, Cefn Cribwr, *c*.1910. This was one of the first commercial coal mines in the area although coal had been dug for centuries by the monks of Margam as well as by local farmers on Cefn Common for domestic purposes. It was not until coke replaced charcoal in the blast furnaces of the ironworks that the production of coal commenced on a large scale in the 1830s. During this period, a coke works was added to the coal mine which had been started at Bryndu prior to 1800.

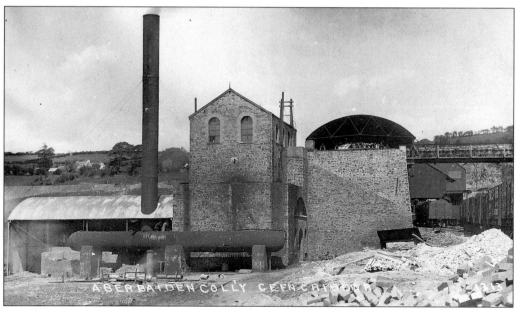

Aberbaiden Colliery, Cefn Cribwr, *c*.1910. The pit was closed in 1959.

Baldwins Limited.—Aberbaiden Colliery.

No................ Name........ *J. Hearse* **17 APR 1920**

Occupation................ Pay week ending................ 19

164

	Rate.	£	s.	d.	DEDUCTIONS.	£	s.	d.
Days	10/10		1	0 0	Dr. Twist			4
					Dr. Cooper			
					Dr. Parry			
					Dr. Richards			
Hours	1 wk		4	0 0	Dr. Kirby			
					Haulage	1	0	
					Check Fund			
					Talbot Institute			6
					Coal	1	2	0
					Powder			
					Advances			
					Collection			
					Coytrahen Hospital			3
					Stores			
Percentage 55·83 %	...	—			Car Fares			
					Ambulance Fund			
					Building Club Subs :—			
				Rents			1	
War Wage	...	1	1	.	Rates			
					Health—Insurance			4
					Unemployment			
Sankey Award	...		14	0	Carriage of Coal		4	4
Total		£6	15	—	TOTAL DEDUCTIONS	£1	14	6
					TOTAL CASH PAYABLE	£5	0	2

NOTICE.—Workmen's Compensation Act.—Any workman who meets with an accident at the Colliery is requested before leaving the Colliery premises to give notice of such accident to the Management, otherwise the claim for Compensation will be resisted.

The pay slip of Mr J. Hearse amounting to £5 0s 2d for the week ending 17 April 1920 at the Aberbaiden Colliery of Baldwins Ltd.

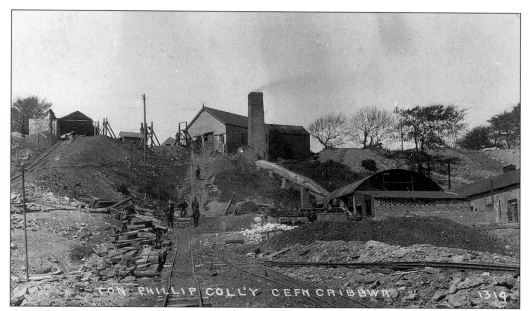

Ton Phillip Colliery, Cefn Cribwr, *c*.1910.

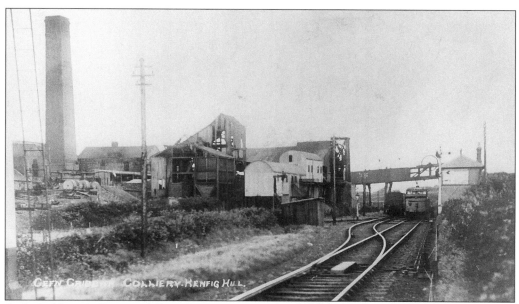

Cefn Cribbwr Colliery, Kenfig Hill, *c*.1910. Note the signal box on the right of the photograph; this has been restored and preserved by Y Cefn Gwyrdd of Cefn Cribwr and is now used as their headquarters.

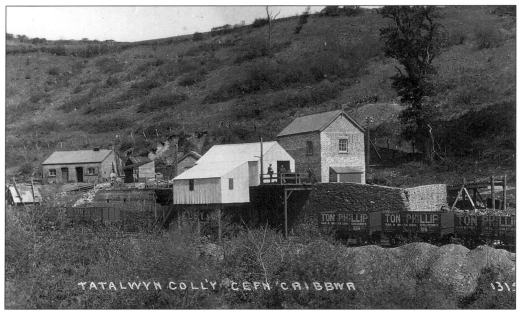

Tytalwyn Colliery, Cefn Cribwr, *c.*1910.

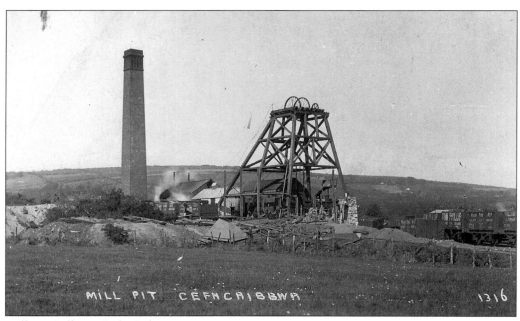

Mill Pit Colliery, Cefn Cribwr, *c.*1910.

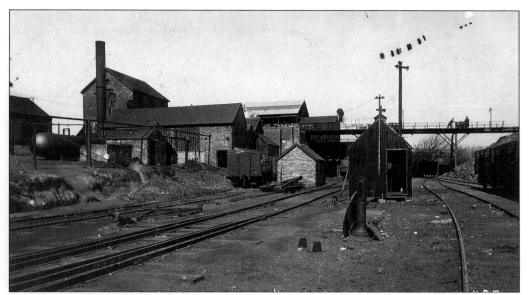

Cribwr Fawr Colliery, Pyle, *c*.1910.

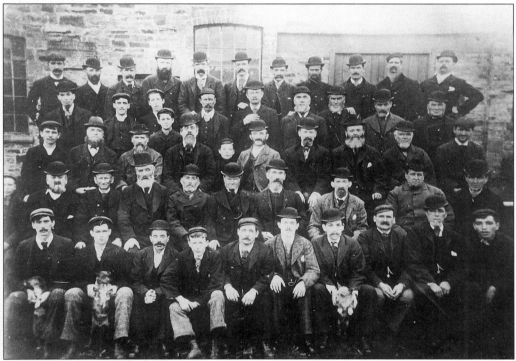

Cefn Slip Colliery officials and workmen, 1889. From left to right, front row: Edward Esaias,
William Evans (Pisgah), -?-, -?-, -?-, -?-, Dan Owen, David Spanswick, Johnny Faithen, Howell
Williams. Second row: -?-, Richard Watkins, William Watkins, Esaias Esaias, -?-, Richard
Roberts. Third row: -?-, John James, John Brown, Llew Mort, Esaias Esaias Jnr., Edward Row, -
?-, John Rowden. Fourth row: -?-, Thomas Thomas, -?-,-?-, John Davies (the Graig), -?-, -?-, -?-,
-?-, Richard Bradshaw, Lewis Morgan. Fifth row: names unknown.

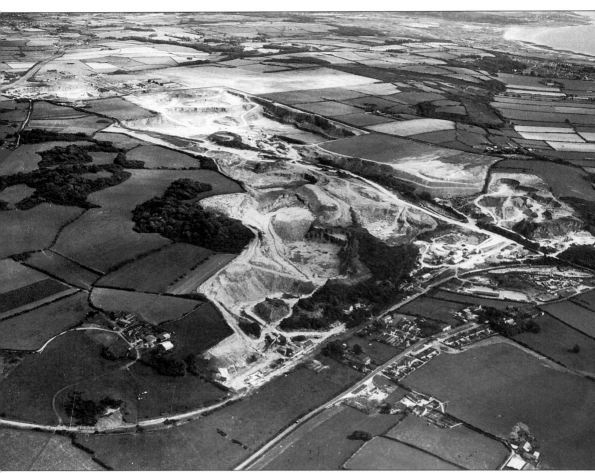

Aerial view of Cornelly Limestone Quarry in the late 1970s. This site has been worked for some considerable time although no extensive quarrying took place until 1916 when it was developed by the contractors engaged in the building of Margam Steelworks. At this time, stone was broken and loaded by hand. In 1919, Baldwins Limited, the owners of the Margam and Port Talbot Works, took over the quarry to provide fluxing stone for the various iron and steelmaking processes. On the formation of the Steel Company of Wales Limited, it was decided in 1946 to mechanise the quarry, this scheme being completed the following year with a planned output of 11,000 tons per week. By 1954, the average weekly output had risen to 13,786 tons with a record weekly tonnage of 20,122 tons being obtained during this year. This pattern continued up to 1966 when the quarry was involved in supplying stone for the new Port Talbot harbour. During the construction of the breakwater for the harbour, peak outputs of 25,000 tons of stone per week were produced and transported to Port Talbot.

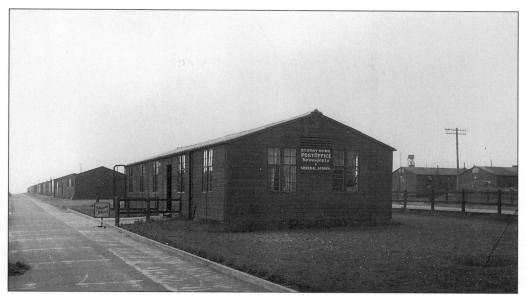

Post office, newsagents & general store, Stormy Down, June 1948. To cater for the large workforce that would be required for the construction of their new integrated Abbey Steelworks at Margam, the Steel Company of Wales Ltd took over the ex-RAF aerodrome and camp at Stormy Down as a workers' hostel. As well as the post office shown above, the complex included a reception and administration office, dormitories, canteen, hospital, library, recreation room with table tennis and billiards tables, and a cinema in what had once been the RAF gymnasium. On arrival, ration books had to be handed in at the administration building and soap coupons exchanged for Food Office coupons.

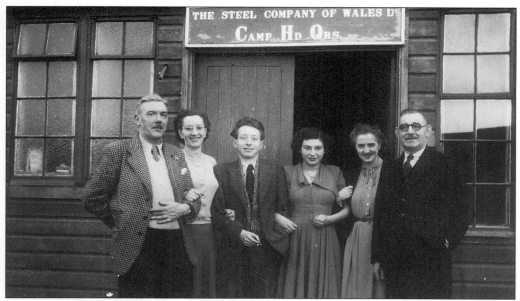

The staff outside the Steel Company of Wales Ltd camp headquarters, Stormy Down, c.1949. From left to right: Mr Eric Philpott, Mrs Elsie Nicholls, Mr Mel White, Miss Malvina Angell, Miss Daphne Twine and Mr Arthur Cloak.

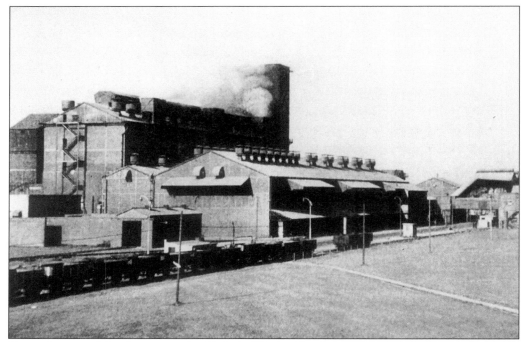

General view of the factory at the Carbide Works, Kenfig in 1966. In the early days of the Second World War, the supply of acetone for the manufacture of cordite smokeless explosive was strictly limited in Great Britain. Acetone is easily derived from calcium carbide but the latter is expensive to produce. Nevertheless, in 1940, the Ministry of Supply chose Kenfig as the site to build their new factory to manufacture calcium carbide. The factory was eventually closed down by the Distillers Company Limited in 1966.

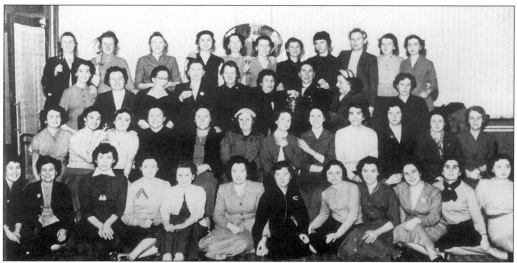

The girls at the Carbide Works, Kenfig, before it finally closed in 1966.

Three
Commerce and Trade

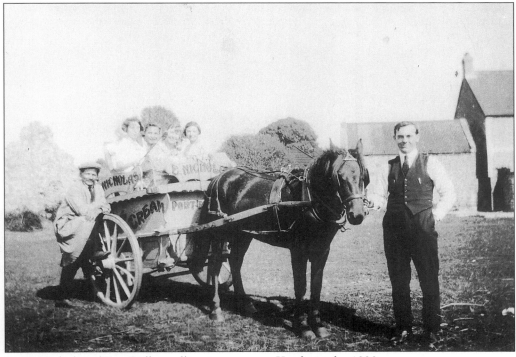

Mr E. Nicholas of Port Talbot selling ice cream at Kenfig in the 1920s.

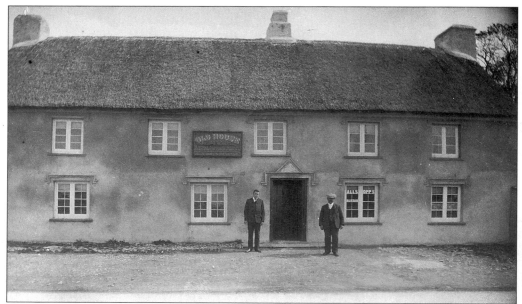

The Old House (The Tap), Pyle, *c.*1910. The premises are now called Ye Olde Wine House.

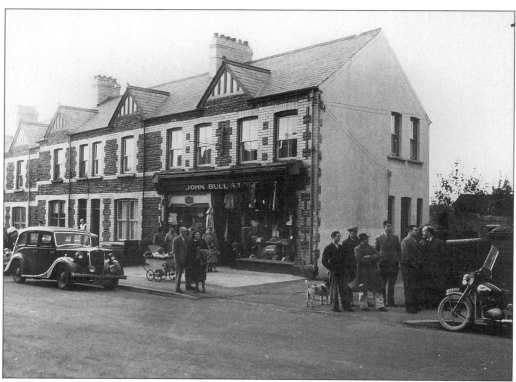

John Bull Stores, Pisgah Street, 1950s.

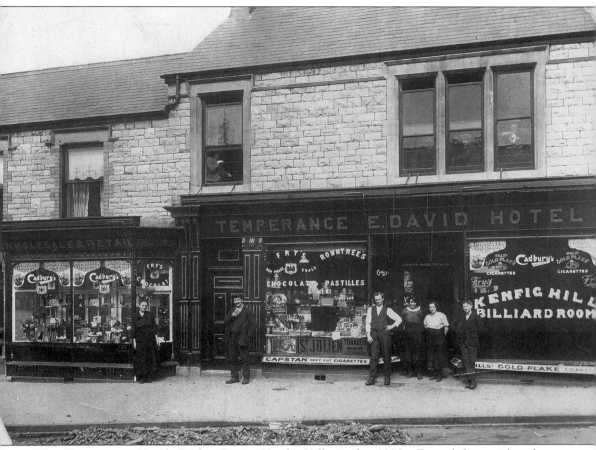

The Temperance Hotel, Bridge Street, Kenfig Hill, in the 1920s. From left to right: the proprietor Mrs E. (Lizzie) David, Dai Delhloff, Will David, Gwyneth Dickinson, Lizzie Brown and Tommy David. The Temperance Hotel, always affectionately referred to as the 'Temps', served as the social hub of village life for several decades. It was originally built as a shop with facilities for a billiard saloon on the first floor. The 'Temps' was truly temperance, but no one knows why it was ever called an hotel as it never served as one. The only letting of rooms was to various organisations for meetings and other social events. It was run by the David family for the whole of its life. Tom David, who opened the Temperance, was a keen sportsman interested in both pigeons and shooting. As a result, in addition to serving as a shop and billiard hall, the 'Temps' soon became the regular venue for a number of clubs. The Pigeon Club was the first to meet here and football teams used it as their headquarters. In the 1930s, it became the 'poor man's university' when the Kenfig Hill Literary and Debating Society was born here. The 'Temps' survived two world wars, strikes and the Depression, holding its own against the wireless and the 'talkies'. However, social fashions and living patterns changed and it passed quietly into history with its many memories of village days gone by when it was sold to become a furniture store in 1955.

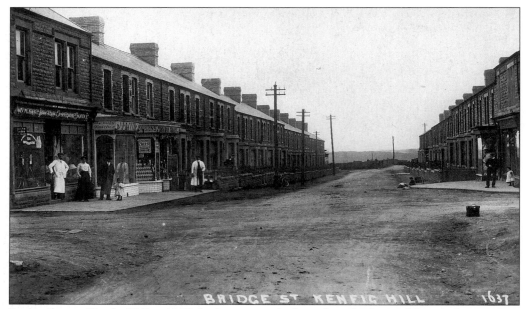

Bridge Street, Kenfig Hill, *c.*1910, looking towards the railway bridge and Pisgah Street. Note that, except for in front of the shops, there are no pavements outside the houses and the road is not surfaced.

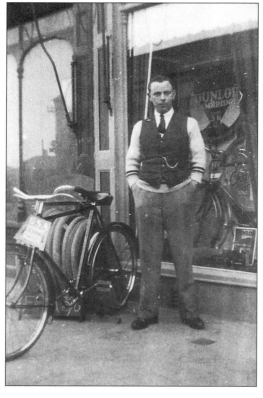

Mr Leo Williams standing outside his ironmonger's shop, no. 8 Bridge Street, Kenfig Hill, *c.* 1926.

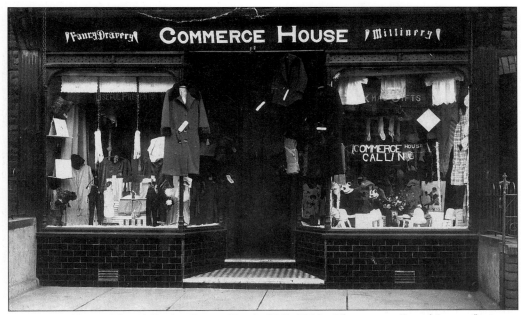

Commerce House, No. 19 Bridge Street, Kenfig Hill, 1930s. This is now David Jones, florist.

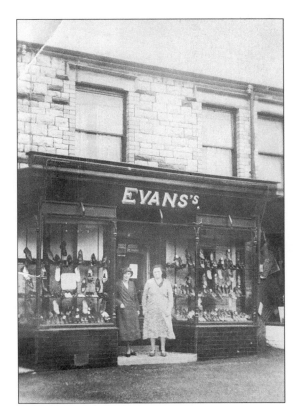

Evans's, footwear, No. 22 Bridge Street,
Kenfig Hill, *c*.1920.

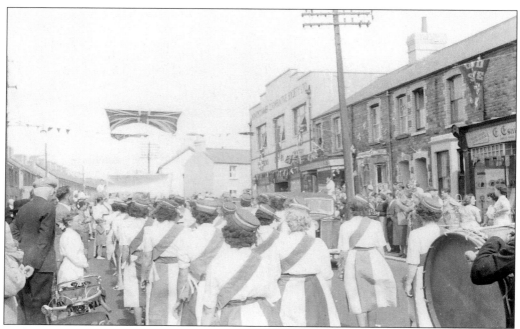

Bridge Street, Kenfig Hill, during the Festival of Britain parade, 1951. The premises of E. Esaias, the ironmonger and funeral director, are on the right with the Pontycymmer Co-operative Society Ltd building in the centre of the photograph. Note Seaview House, on the corner of Waunbant Road, later demolished to make way for the Jet garage.

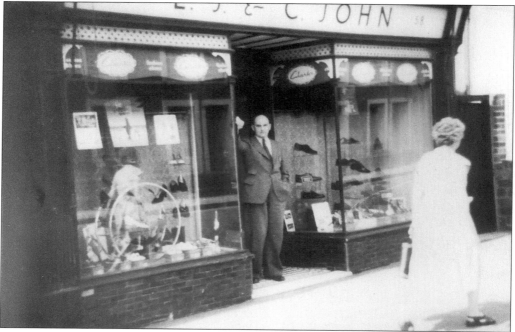

E.J. & C. John, No. 58 Commercial Street, Kenfig Hill, in the 1950s. Mr Eddy John is pictured standing in the doorway of the footwear shop which he co-owned with his sister, Cissie.

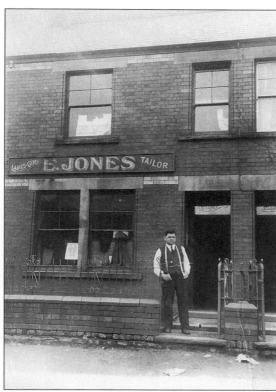

Mr E. Jones, ladies & gents tailor, standing outside his establishment at No. 15 Commercial Street, Kenfig Hill, pre-1939. The premises are now occupied by the Midland Bank.

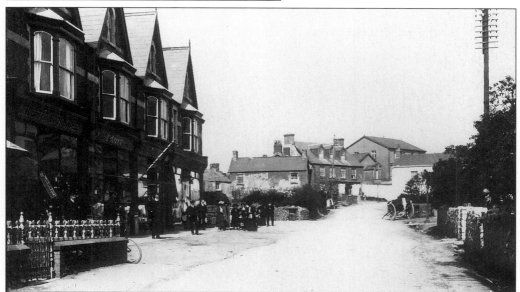

Bowen's Cross, Kenfig Hill, *c.*1910. This is now generally referred to as the Top Cross. The first shop on the left is the Leicester Boot Stores while the third is that of the barber as the characteristic spiral pole advertising his trade can be clearly seen. Note the old cottage in the centre of the picture with Moriah Chapel in the background. The village well or 'pistel' is set in the dry-stone front garden wall of the cottage.

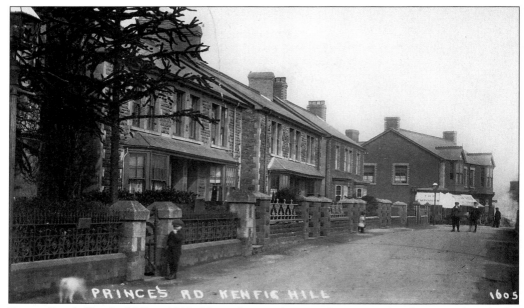

Prince Road, Kenfig Hill, *c.*1910. Note the monkey puzzle tree in the foreground with the emporium of William Rees and the ironmongery store of Howell & Protheroe in the distance. The last two houses on the left, with the gas lamp standard outside, have yet to be converted to shops. One of them was later to be occupied by John Jones, family butcher.

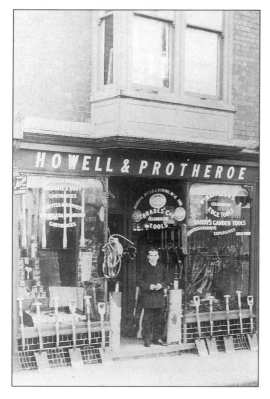

Howell & Protheroe, ironmonger's, Prince Road, Kenfig Hill, *c.*1910.

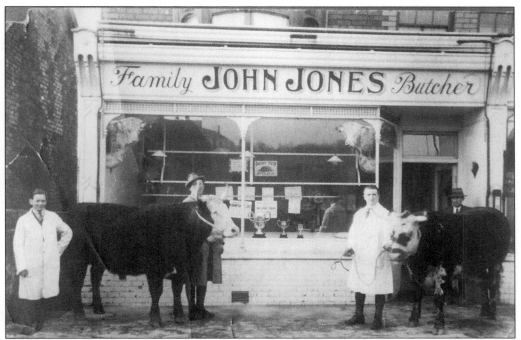

John Jones, family butcher, *c.*1932. The shop is still a butcher's and is now owned by David Phillips. Mr John Jones died in August 1995 in his 94th year.

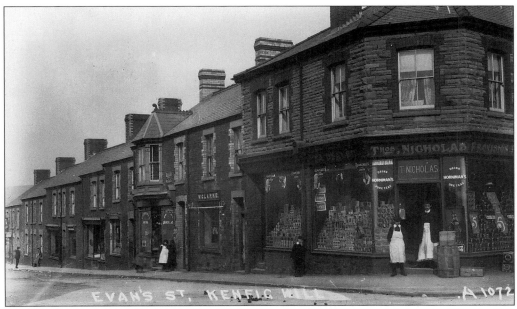

Evans Street, Kenfig Hill, *c.*1910. This used to be part of the commercial centre of Kenfig Hill being nearest to the industrial area. The grocer's shop of Thomas Nicholas has now been closed and converted back to a dwelling place.

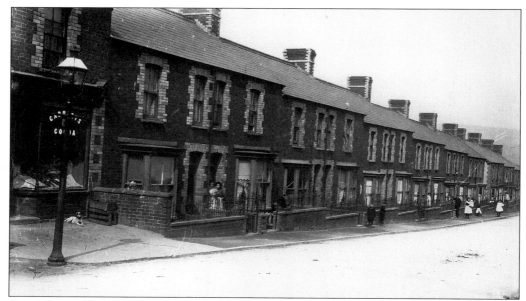

Evans Street, Kenfig Hill, c.1910. The shop on the corner has also been closed and converted into a house.

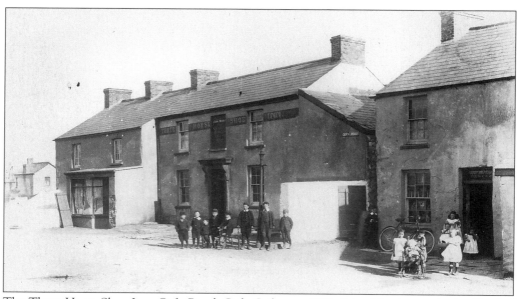

The Three Horse Shoe Inn, Cefn Road, Cefn Cribwr, c.1910. John Morris was the landlord of the inn while the grocer's shop to the right was owned by Dai Hopkins. Note the wooden shutters, left, leaning on the wall of Mock Richards' drapery shop.

Four

Transport

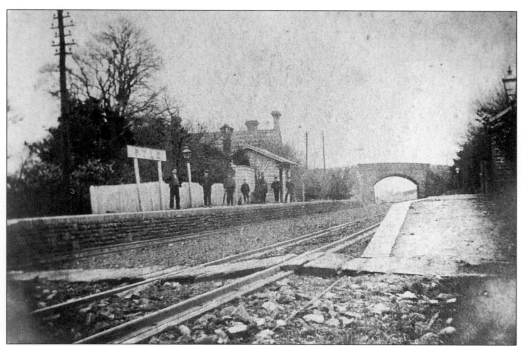

Staff at the first Pyle railway station, late 1890s. This station was built in 1850 when the South Wales Railway was opened and was located on the Swansea side of the A48 road bridge. What is now the Crown Inn public house was once the station-master's office and the ticket office. Note the old broad gauge track. When the first train rumbled through on its way to Swansea in 1850, schoolchildren were given a day off so that they could witness the memorable occasion.

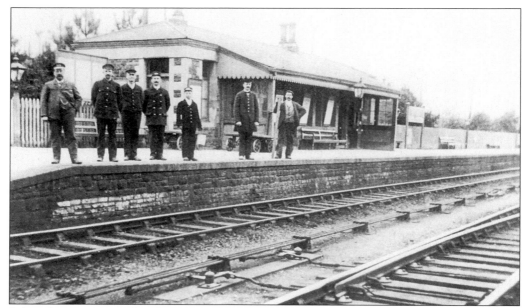

Pyle railway station and staff, c.1914. This was the second station to be built and was located on the Bridgend side of the A48 road bridge. In its heyday, as a GWR main line station, it boasted four platforms with a well appointed waiting room on each, two footbridges, a booking office, together with a goods yard and extensive sidings. Pyle station was an important junction for excursions to Porthcawl and was also one of the best kept with lawns, shrubbery, flower beds and even a goldfish pond complete with fountain.

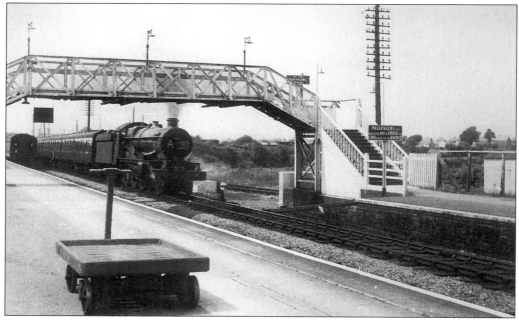

Swansea-Paddington express, drawn by a 'Castle' class locomotive, passing through Pyle station at speed in September 1962. The station goods yard, which is to the right of the engine, is now occupied by the Pyle Garden Centre.

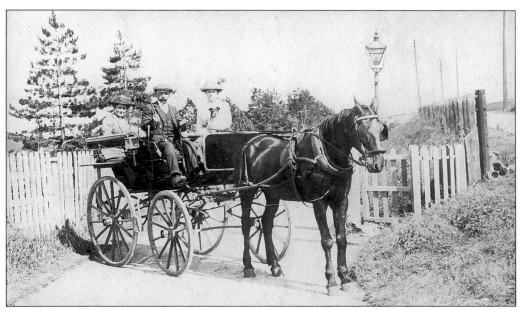

Ted 'the Bolt', a pioneer in the taxi business, with fare, c.1910. Pyle station was approached by a private company road, lined on one side with large pine trees, which led to an extensive yard where horse-drawn brakes and, later on, motor cars awaited train arrivals.

Frank Cound's taxis at Pyle station in the 1920s with the drivers and railway staff killing time while waiting for the next train.

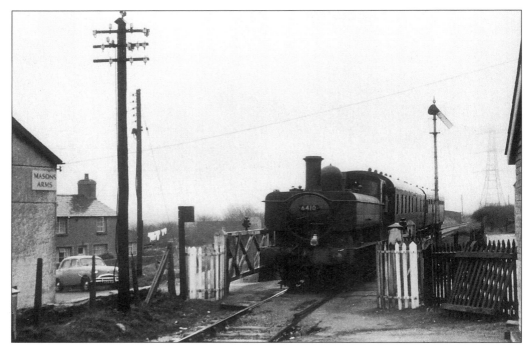

A 6400 'Pannier' class tank engine (No. 6410), working empty stock between Tondu and Pyle, passing through the level crossing gates by the Masons Arms, at the junction of Crown, Station and Victoria roads, Kenfig Hill, November 1962.

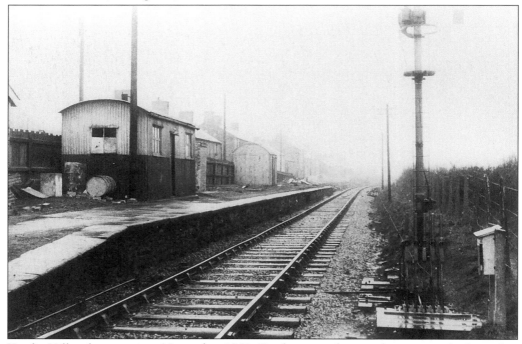

Kenfig Hill railway station, November 1962. By this time the stop here was a shadow of its former glory; in the early 1900s it had boasted a station-master supported by at least six staff.

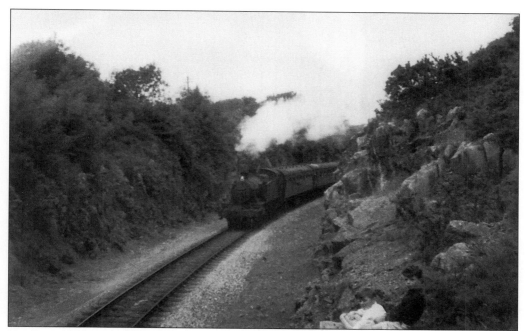

Train *en route* to Porthcawl passing through the cutting at Smokey Cote, South Cornelly, 1960s.

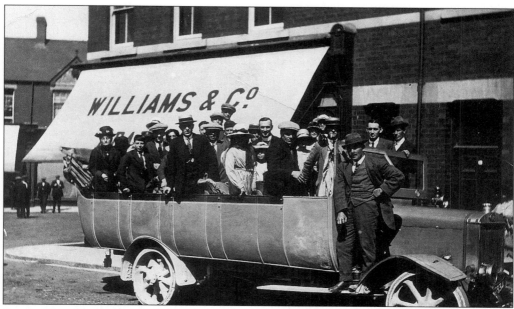

Express Motors charabanc ready to set off from the Top Cross, Kenfig Hill, on a St Theodore's Church choir outing, *c*.1920. Mr John Evans is standing on the running board. Note the solid tyres and the hood folded down at the rear of the vehicle.

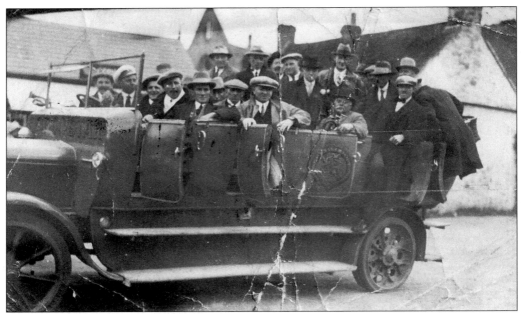

Colliers' outing, 1920s style. The charabanc belonged to Evan John & Son, Kenfig Hill.

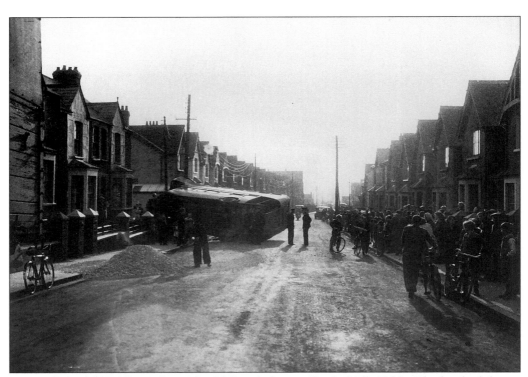

Bus crash outside Wilkins' shop, No. 35 Pisgah Street, Kenfig Hill, 1950s. The bus had driven over a pile of chippings on the side of the road causing it to tip over. Note the pram that it crushed; the baby inside was snatched to safety only moments before the accident.

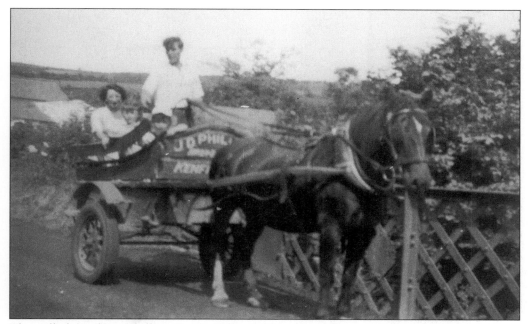

The milk dray of J.D. Phillips, Kenfig Hill, *c*.1953.

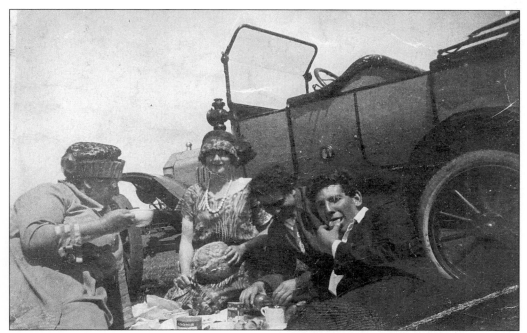

The advent of the family car. The Angell family of Kenfig Hill picnicking at Kenfig in the 1920s.

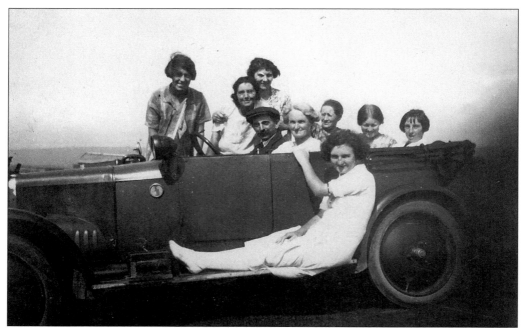

Getting the most out of the family car – the Waite family of Kenfig Hill at Kenfig in 1926. Cassie Waite is pictured in the rear seat with Janet Waite doing a balancing act on the running board.

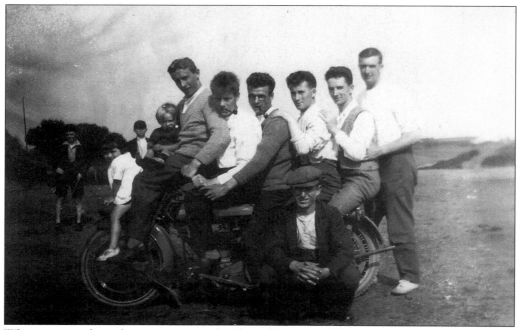

What you can do with a car you can also do with a motor bike. At Kenfig in the 1920s with seven passengers; was this a record?

Five

Religion

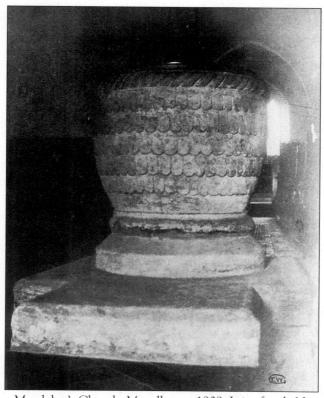

The font in St Mary Magdalen's Church, Mawdlam, *c*.1909. It is of early Norman origin with a distinctive fish-scale pattern all over and rope rim to its upper edge. The font occupies more than its fair share of space in the church, supporting the theory that it was not designed for St Mary Magdalen's, but rather it was brought here from the original St James' Church when that was inundated with sand. A similar, but smaller font can be seen in Llantwit Major church.

Mothers' Union group outside St Mary Magdalen's Church, with the vicar David Davies, on the occasion of a special service for the church's 700th anniversary celebrations.

The Kenfig Calvinistic Methodist Sunday school assembled outside the Prince of Wales, Kenfig, in the 1950s. The Sunday school was formed by Mr and Mrs Richard Bowen c.1863, together with Mr Evan Howell, Mr Edmund Thomas and Mr William Rees, who were the other chief founders. Initially, the Sunday School was held in Mr and Mrs Bowen's home at Ton Kenfig, but it was transferred in the same year to the hall on the first floor of the Prince of Wales. This hall was the Guildhall or Corporation House of the Borough of Kenfig. The Sunday school has continued to be held here regularly ever since. The average attendance when it celebrated its centenary year in 1963 was 40 pupils. Compare this to August 1923 when a record 75 pupils attended the school.

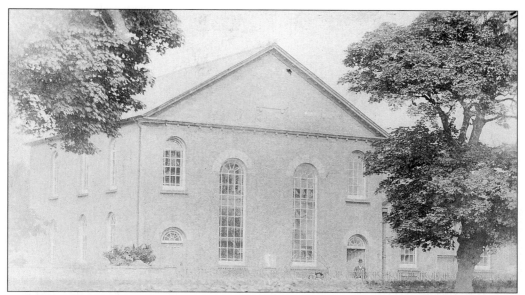

Capel-y-Pil, Pyle, *c.*1910. The chapel celebrated its bi-centenary in 1986. William Thomas of Ty Draw was the sole inspiration behind the founding of the chapel and the establishment of the Methodist cause in the area. He bought three cottages and ground in Cornelly on which to build a chapel. The first Capel-y-Pil, what is now the vestry, was opened in 1786. Such was the success of the chapel that a new building was erected in 1836 and yet another one, the present building, in 1862.

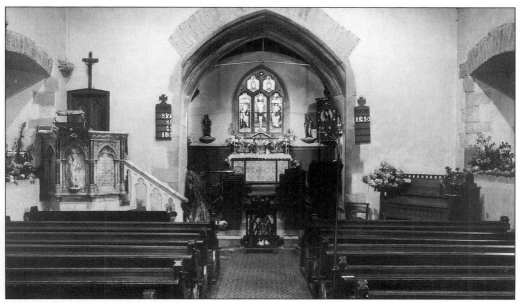

The interior of St James' Church, Pyle, *c.*1950.

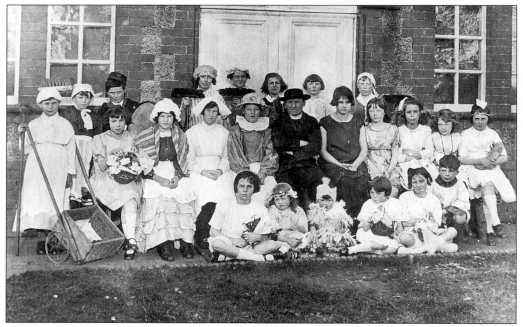

Pyle children's concert, 1925. The vicar of Pyle and Kenfig, the Revd D.G. Arthur is sitting in the centre of the group.

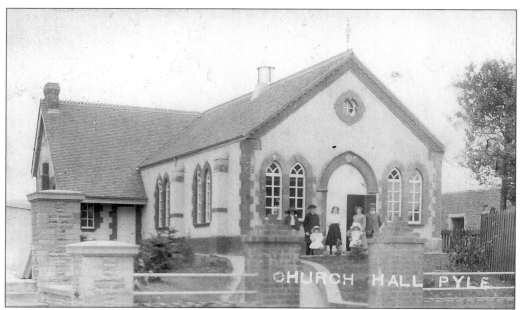

The church hall, Pyle, in the early 1900s.

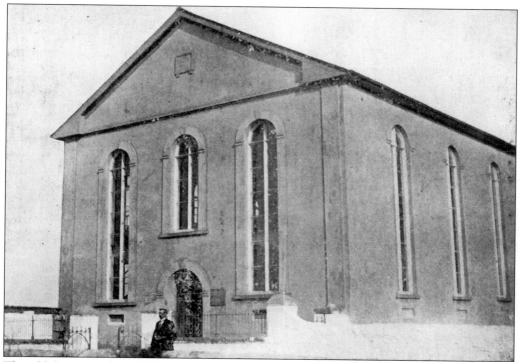

The old (or second) Pisgah Chapel, Kenfig Hill, before 1912, the year it was demolished to make way for the present chapel. Foundation stones were laid for the new chapel on 30 April 1912 and it was opened the following year. Prior to the old or second chapel being built, services were held in the barn of Pwll-y-Garth farm.

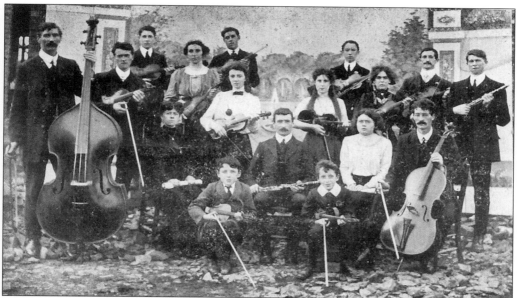

The Pisgah Chapel orchestra, 1913.

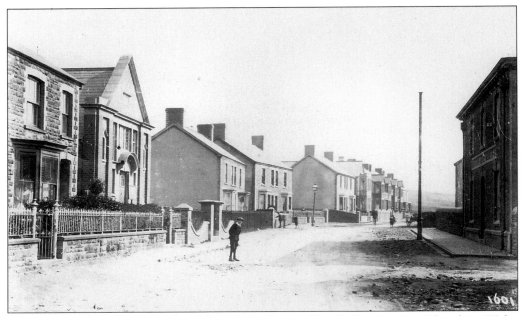

View of Waunbant Road, Kenfig Hill, with the first St David's Presbyterian Church in Wales on the left of the photograph. This was built in 1909; the second church was not erected until 1928.

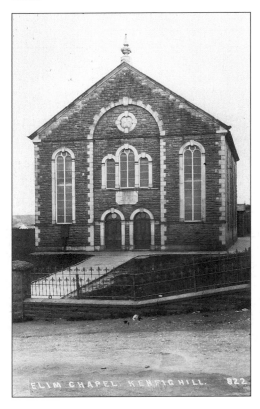

Elim Chapel, Kenfig Hill, c.1907. Sadly, the chapel was demolished early in 1995.

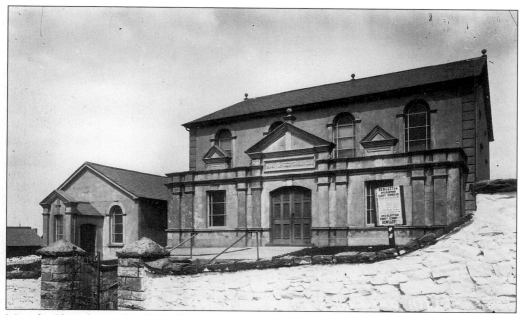

Moriah Chapel, Kenfig Hill. The notice outside the chapel advertises a by-election for a County Council seat in the Newcastle constituency to be held on Saturday 13 April 1907, thus firmly fixing the date for this photograph.

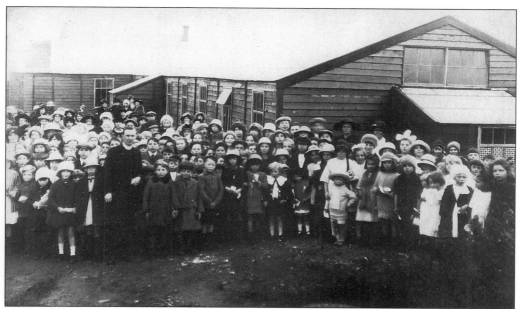

Sunday school party to celebrate the official opening of the first St Theodore's Church Hall in Margam Row, 11 October 1922. The vicar of Kenfig Hill, the Revd John Francis, is standing to the left of the group.

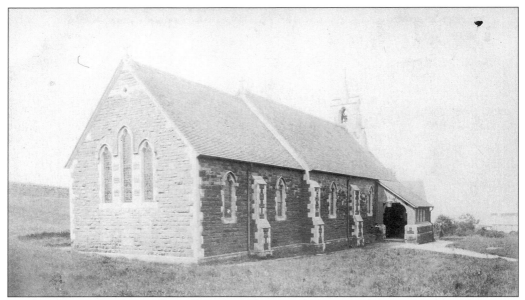

St Theodore's Church, Kenfig Hill, *c*.1905, showing the extent of the original building. Miss Emily Charlotte Talbot laid the foundation stone on 19 November 1888 and the church was dedicated by the Bishop of Llandaff on Monday 10 June 1889.

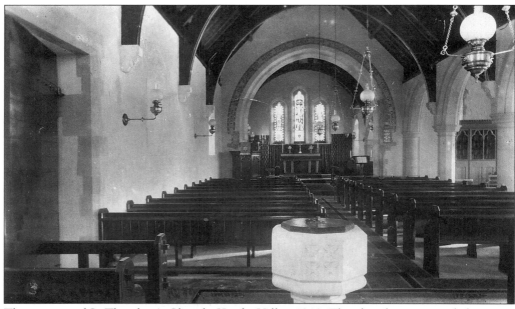

The interior of St Theodore's Church, Kenfig Hill, *c*.1910. The church was extended in 1909 and the new south aisle and vestry, which were added at that time, can be seen on the right of the photograph.

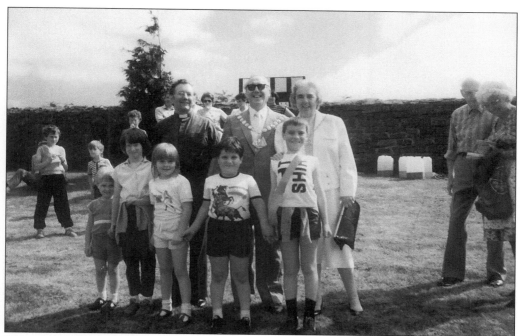

The vicar of Kenfig Hill, the Revd Godfrey James MA with the winning sports team at the St Theodore's Church annual fête, July 1986. The prizes were awarded by County Councillor Mostyn Jones, MBE, DL, Chairman of Mid Glamorgan County Council and Mrs Margaret Jones.

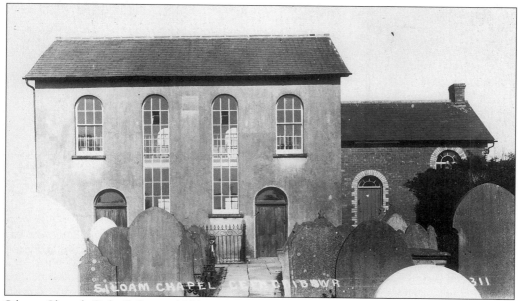

Siloam Chapel, Cefn Cribwr, *c.*1910.

Nebo Chapel, Cefn Cribwr, *c*.1910.

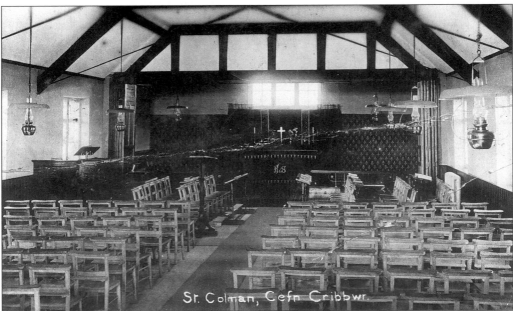

The interior of St Colman's Mission Church, Cefn Cribwr, when it was opened on 5 February 1925. On 5 July 1924 foundation stones were ceremoniously laid thus marking the 'birth' of St Colman's Church. The late Mrs Emily Langdon was able to recall that the service of dedication was held in the open air by the Revd H.R. Protheroe, vicar of Penyfai. The church was formally opened and dedicated the following year by the Rural Dean, the Revd D. Phillips.

Six
Education

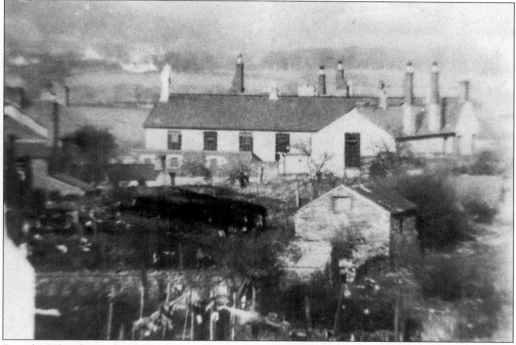

Bryndu School, Kenfig Hill, *c*.1914. About 1857 the Hon. C.R.M. Talbot, MP, of Margam, the owner of Bryndu Slip Colliery, started a temporary school in the colliery stables. This very soon became known as the Bryndu Works school, but it could only be used for this purpose while the ponies and horses were working down the pit, leaving the stables empty. More permanent accommodation was thus sought and in the early 1860s Bryndu School was built at the end of School Road. It was eventually demolished in 1957. During its existence, the school was also used for regular church services. Amid abuse and harassment, the Revd John Bangor Davies held the first service in the school in the autumn of 1878. He eventually overcame the opposition and both regular services and Sunday school became a well established way of life at Bryndu School until St Theodore's Church was opened on 10 June 1889.

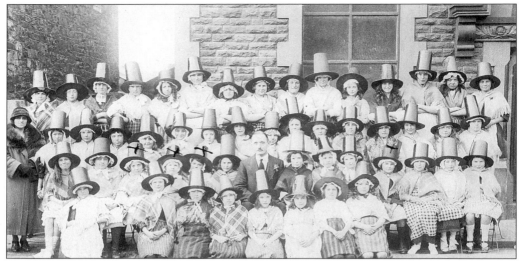

Bryndu School, St David's Day group, late 1920s. Mr Richie L. Williams, who was Headmaster of Bryndu School from 1910 to 1929, is seated centre. Mrs Lilli Griffiths (née Stubbs) is kneeling second from right in the front row and Miss Milli Twist is sitting fourth from the right in the second row. On 17 April 1887 at the age of twenty-one, Mr Williams had the distinction of being baptised by the Revd Bangor Davies, curate of Kenfig Hill. However, this was no ordinary baptism. At the conclusion of Sunday school on that day, a procession marched to the river at a point three hundred yards to the east of Crown Road. Here the reverend gentleman entered the water and publicly baptised Richard Leyshon Williams. The ceremony was most impressive and was witnessed seemingly by all the inhabitants of Kenfig Hill and Cefn Cribwr. The Revd John Bangor Davies attested to this event in the official baptism record by noting beneath his signature: 'by immersion in the river'.

Bryndu School teachers, 1930s.

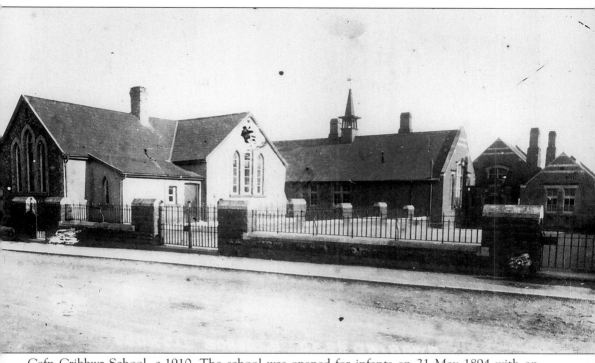

Cefn Cribbwr School, c.1910. The school was opened for infants on 21 May 1894 with an attendance of fifty-six. At this time, Miss Annie Thomas was the certified mistress in charge with Elizabeth Rosser as monitress. Miss Thomas retired in March 1930 after completing 36 years as head teacher. Long service was a characteristic of the school; Miss Adams followed as head for 9 years and Miss Lewis taught here for 31 years, 22 of them as Head Teacher. Miss E. Granville retired on 1 February 1946 after 46 years faithful service while Mrs Dunphy taught here for 25 years, twelve of them as head teacher of both the infants and junior schools. Until the 'big school' was built for the juniors in 1902, older children attended Bryndu School at Kenfig Hill. In 1914, the infants' school was largely rebuilt. Frequent official holidays were given for important events such as the visit paid to Cefn Cribwr on 28 April 1924 by Mr Ramsay MacDonald, the Prime Minister. Both infants and junior schools were amalgamated under one head teacher, Mr W.J. Morris, on 1 September 1962, by which time Cribwr had lost a "b".

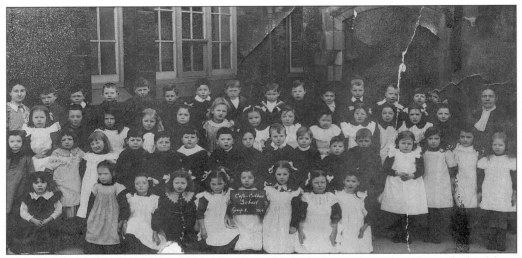

Cefn Cribbwr School, Group 2, 1914. Mrs Mary Elizabeth Davies (née Evans) stands third from the left in the second row while the late Mrs Emily Langdon (née Wilmot) stands fourth from the right in the first row.

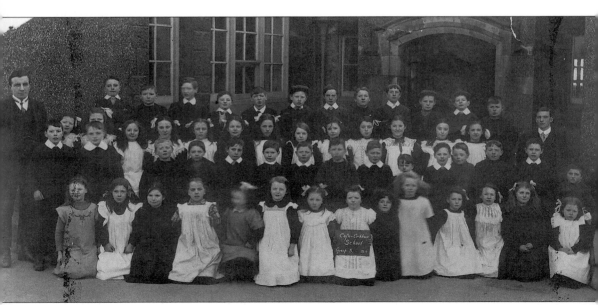

Cefn Cribbwr School, Group 5, 1914.

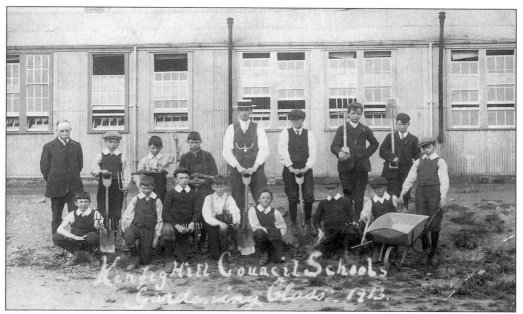

Gardening class at Kenfig Hill Council School, 1913. The headmaster, Mr D.H. Price, is on the left. Until 1942, when it burnt down, it was know as the 'Old Tin School'. The main entrance wing of the replacement Mynydd Cynffig Junior School was also destroyed by fire in June 1983.

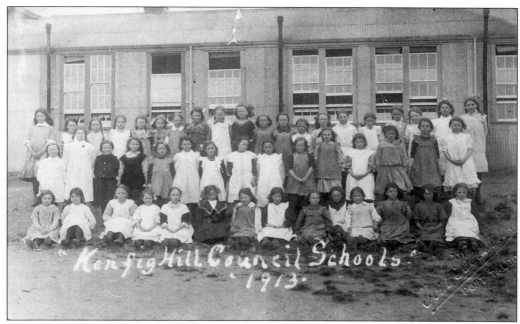

The girls of Kenfig Hill Council School, 1913.

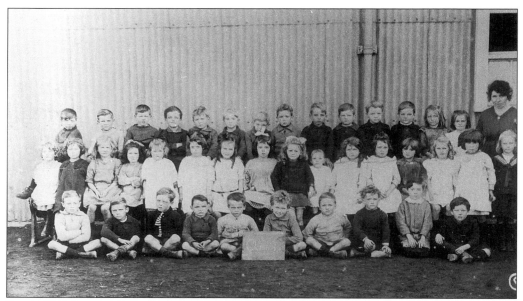

Kenfig Hill Council School, Class 1a, September 1921.

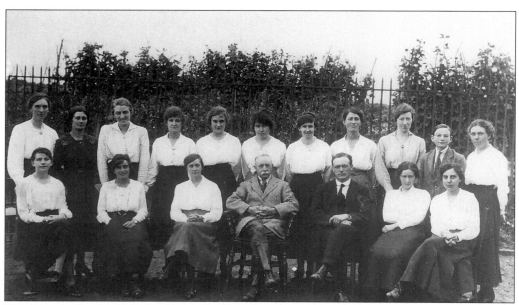

Teachers at Kenfig Hill Council School, c.1921. Mr D.H. Price, the headmaster, is seated centre.

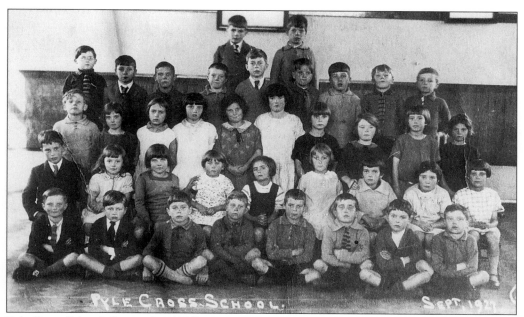

Pyle Cross School, September 1927.

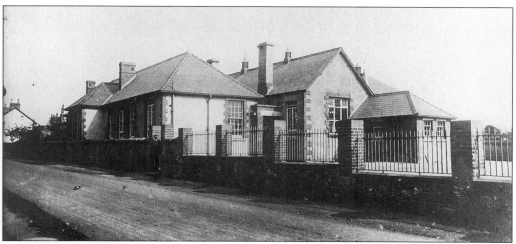

Cornelly Council School, 1915. This is now Ysgol Y Ferch O'r Sger, Corneli.

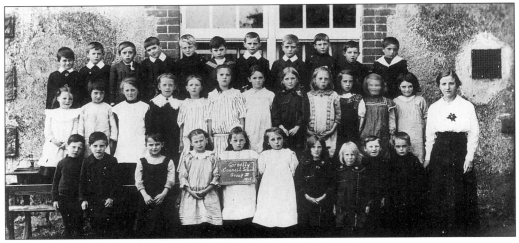

Cornelly Council School, Group III, 1915.

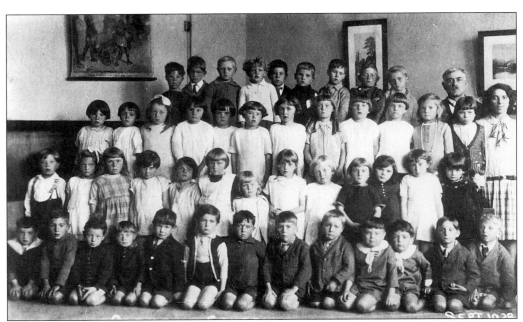

Cornelly School, September 1928. The headmaster, Mr Davies, is at the back with teacher Miss J. Morgan.

Seven
Organisations

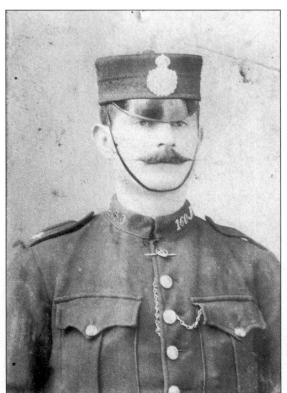

P.C. No. 160 J. Ivor Evans, police constable at Cefn Cribwr and Kenfig Hill in the latter part of the nineteenth century. He was following in the footsteps of his father, P.C. Edward Evans, who had been a police constable at Cardiff and Pencoed as well as at Pyle and Kenfig Hill. P.C. Ivor Evans eventually moved on to Pentre, Cwmavon and Aberdulais. Following retirement, he lived at Cefn Cribwr until his death on 18 August 1896, aged 60; he was buried at Dinas Powys.

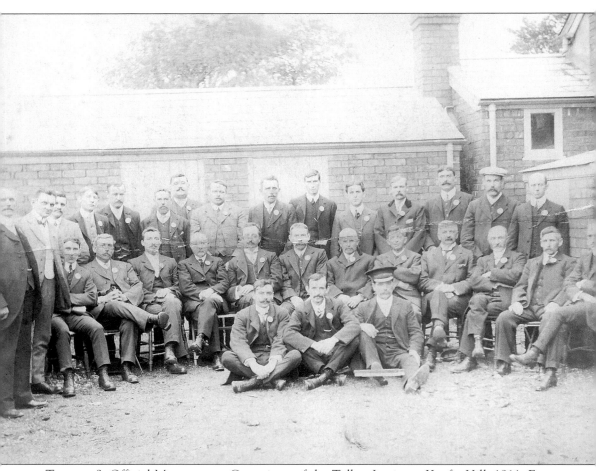

Trustees & Official Management Committee of the Talbot Institute, Kenfig Hill, 1911. From left to right, front row: T. Jenkins; M. Morgan; W. Hopkins (caretaker and librarian). Second row: E. Williams; E. Morgan, ME (Chairman of Reception Committee); R.T. Hall; D.H. Price (Treasurer); G. Knott, Esq., JP (Concert Chairman); George Myers (Chairman of Management Committee); W.E. Thomas, ME; G. Thomas (trustee); J.F. Twist MD (trustee); T.J. Davies (trustee); D. Thomas; Revd A.S. Jones BA (trustee). Standing: J. Jenkins; T.M. Richards (Secretary); T.J. Francis; J. Powell; J. Jones; W. Thomas; E. Phillips; W. Moles; D. Roberts; J. Mackenzie; T.M. Jenkins; E. Reed; A. Jury; A. Jenkins; I. Harding. The Talbot Institute at Kenfig Hill, built at a cost of £2,000, was presented to the District by Miss Talbot of Margam, on Wednesday 20 September 1911. It was officially opened on that day by Mr G. Lipscomb, agent to the Margam Estate. The building was divided into three sections: one for games, one for newspaper reading, and a third as a reference library and magazine room. The games room contained two billard tables (one full size) together with several chess and draughts boards. The newspaper section was furnished with the usual daily and weekly papers, and the reference library was provided with about 4,000 standard volumes of literature. Lighting throughout was by acetylene gas. There were some eight hundred people present at the opening ceremony, after which, trustees, officers and others retired to the Prince of Wales Hotel for a splendid cold buffet at which Mr G. Knott presided and the Kenfig Hill Male Voice Party provided the musical entertainment.

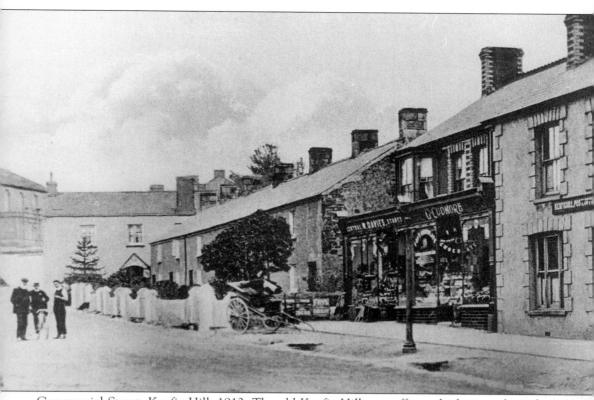

Commercial Street, Kenfig Hill, 1912. The old Kenfig Hill post office, which is on the right hand side of the photograph, also housed the Kenfig Hill manual telephone exchange. This exchange closed at 1.30 pm on Tuesday 9 March 1954 and was replaced by a new unattended automatic telephone exchange that had been built in Waunbant Road. The closing of the old manual telephone exchange, which first came into operation in 1900, ended a long association between the subscribers in the area and the postmistress, Mrs S.A. Davies, her father and her family who had kept the post office at Kenfig Hill. They had attended the manual telephone exchange faithfully night and day for 54 years; as the 1904 Telephone Directory had proudly stated: 'The Exchange is open always'. Mrs Malvina Morgan (née Angell) recalls being employed and trained by Mrs Davies to operate the manual telephone switchboard between 1945 and 1948. At that time, Malvina was also expected to send and receive telegrams as well as to deliver them on foot throughout the area. Her grandfather, Mr Sydney Charles Angell had been the local postman from the late 1880s up to his retirement in the 1930s.

KENFIG HILL.

(The Exchange is open always.

The Telegraph Engineer (Glamorgan Section), Post Office, Cardiff—
Telephone No. 551.

1	CALL OFFICE - - -	Post Office.
12	**Baldwin's**, Limited, Iron and Steel Manufacturers.	Aberbaiden Colliery.
2	**Cefn Cribbwr** Brickworks -	Cefn Cribbwr.
3	**Davies**, J. H., M.D., J.P. -	The Laurels.
4	**Hughes** Brothers, Provision Merchants.	1, Victoria Buildings.
6	**Jones**, T., Surgeon - -	The Surgery, High Street.
7	**Thomas**, T., Licensed Victualler.	Crown Inn.
10	**Thomas**, W. H. - -	Maudlam, Kenfig Hill.
8	**Woodward**, J., Fish Merchant and Florist.	8, School Road.

MAESTEG.

The Exchange is open always.

Engineer—S. G. BRYANT, Post Office, Cardiff—Telephone No. 551.

1	CALL OFFICE - -	Post Office.
24	**Conservative** Club - -	14, Talbot Street.
12	**Davies**, D., Grocer -	Post Office, Nantyffyllon.
36	**Davies**, D. T., Auctioneer -	21, Talbot Street.
32	**Davies**, E. E., Solicitor -	Talbot Street.
20	**Davies**, Thos. K., Accountant	10, Bridge Street.
2	**Davies**, Wm., & Co., Fruiterers.	Llynvi Stores.
17	**Elders** Navigation Collieries, Limited.	Garth Colliery.
7	**Gilbert** & Co., Mineral Water Manufacturers.	Church Street.
3	**Isaac**, Wm., Draper - -	115 & 116, Commercial Street.
31	**James**, J., Printer - -	Caxton House.
33	**Jenkins**, Wm., General and Furnishing Ironmonger.	Commercial Street.
13	**Jones**, T. H. - -	Three Horse Shoes Hotel.

In the 1904 Post Office telephone directory for the area, Kenfig Hill shared a page with Maesteg. Four years after its opening, the manual telephone exchange at Kenfig Hill still had only twelve lines connected to the switchboard, and two of these were spare.

THE POSTMAN'S COMPLIMENTS.

Having endeavoured to faithfully discharge my duties in the past, and hoping that I have merited your appreciation, I heartily wish you

𝕬 𝕸𝖊𝖗𝖗𝖞 𝕮𝖍𝖗𝖎𝖘𝖙𝖒𝖆𝖘 𝖆𝖓𝖉 𝖆 𝕳𝖆𝖕𝖕𝖞 𝕹𝖊𝖜 𝕴𝖊𝖆𝖗

C. ANGELL.

'Postman's Compliments' – a Christmas and New Year card handed out by the local Kenfig Hill postman, Mr Charles Angell, at the turn of the century.

POST OFFICE NOTICE.

V. R.

On and from the 1st July, 1890, Money Order, Postal
Order, Savings Bank, Stock Investment, Life Insurance
and Annuity business will be carried on at the Sub Post
Office at KENFIG HILL.

The hours for these branches of business will be as
follows, viz. :—

POSTAL ORDERS.

Issued 7 a.m. to 8 p.m.
Paid 9 a.m. to 8 p.m.

MONEY ORDER, SAVINGS BANK, &c., BUSINESS.

Ordinary Week days.... 9 a.m. to 6 p.m.
Saturdays 9 a.m. to 8 p.m.

INLAND MONEY ORDERS.

The charges for Inland Money Orders are—

For sums not exceeding £1..2d.
 ,, above £1 and not exceeding £2................3d.
 ,, ,, £2 ,, ,, £4................4d.
 ,, ,, £4 ,, ,, £7......5d.
 ,, ,, £7 ,, ,, £106d.

Notice from the Postmaster-General announcing that with effect from 1 July 1890, money and
postal orders would be available from the sub post office at Kenfig Hill.

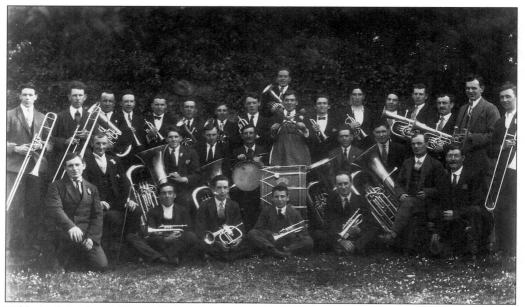

Baldwins brass band, Kenfig Hill, 1920s.

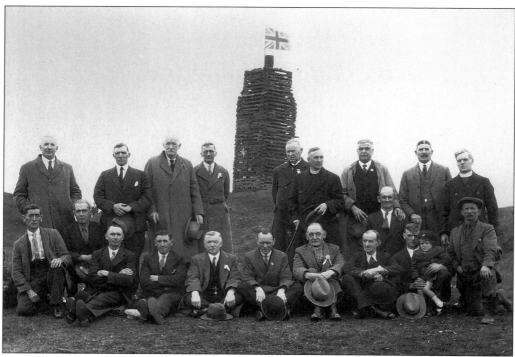

Pyle and Tythegston Silver Jubilee Committee, 6 May 1935. From left to right, standing: J.L. Tranter, Tom John, W. Abel, W.R. James ME, J. Jenkin Jones JP, Revd J. Francis, Sgt Morgans, F. Jury, Revd G. Davies. Seated: D. Richards, A. Morgans, George Thomas, Lewis Jones, Tom Thomas, B. Cameron DC, R.L. Williams DC, Moses Morgan, George Butcher, Glan Evans, W. Watkins.

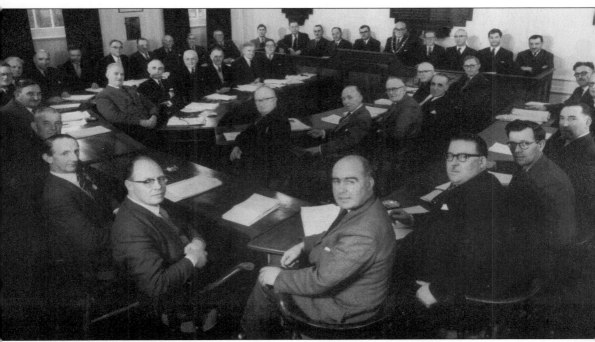

Members of the Penybont Rural District Council for 1960-61. Up to 1974, when it was replaced by Ogwr Borough Council, Penybont RDC was responsible for the administration of the districts covered by this book.

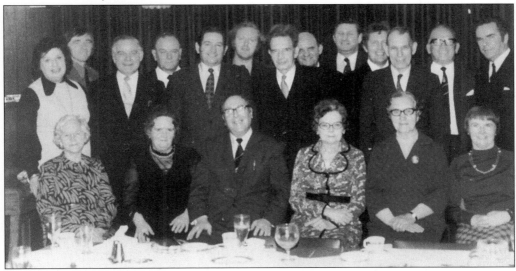

Members of the last Pyle Parish Council prior to the re-organisation of the parish councils in 1974. From left to right, seated: Mrs Matti Thomas; Mrs Nancy McCormick; County Councillor Mostyn Jones MBE, DL (Chairman); Mrs Evelyn Waite; Mrs May Wills; Mrs Edwina Burgess. Standing: Mrs Megan Little; Mr Rex Chess; Mr R.T. Jack Jones; Mr Ivor Flower; Mr Bill Humphreys; Mr Allan Jones; Mr Charles Power (Clerk to the Council); Mr Fred Taylor; Mr Gwyn Williams; Mr Bob Perham; Mr Trevor Hopkin; Mr Graham Harries; Mr Andrew Summers.

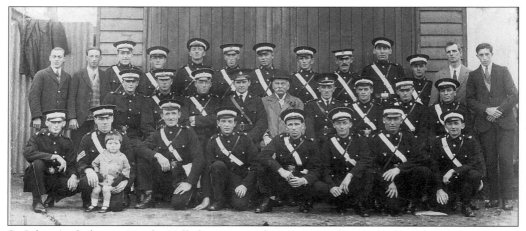

St John Ambulance, Kenfig Hill division in the 1920s, with Dr Cooper seated centre. The ambulance movement in Kenfig Hill can be said to have really started in 1909 when the first class was held at Kenfig Hill School (presumably the 'Old Tin School') for the purpose of rendering first aid to the injured. After two years a committee was formed and this met at the home of Dr Cooper. First aid work grew to such an extent that from 23 March 1912, classes and meetings were held in the Talbot Institute. At this time, rules were drawn up by the committee thus officially forming the Kenfig Hill division. The Cefn Cribbwr division was formed the following year. Prize draws were organised and concerts held in order to raise funds to buy uniforms for the Kenfig Hill division. Equipment and stretchers were kindly donated to assist with the 120 injuries that were being treated on average each year.

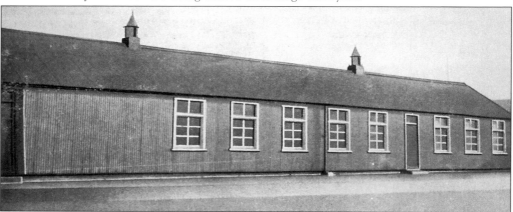

The Ambulance Hall, Kenfig Hill, 1937. This hall was built in 1914 at a cost of £190. It was located to the north of Mynydd Cynffig Junior School on the site now occupied by the Air Training Corps headquarters. At the time of celebrating its twenty-fifth anniversary in 1937, the Kenfig Hill division consisted of 23 ambulance-men with a nursing division of 14 and a cadet force of 25. The division was a force to be reckoned with as it had become a fine team winning cups and shields at National Eisteddfod ambulance competitions. In 1924, the St John Priory of Wales stationed an ambulance car at Kenfig Hill. This was initially housed near the Ambulance Hall. Later, after the hall was taken down, the ambulance was kept in a garage on Pisgah Street, just across the road from Pyle branch library. This building still exists, but the Ambulance Hall, however, was demolished in the late 1970s. Sadly the number of members diminished and in 1984 a fine tradition ended when the division was wound up for practicable purposes due to death and retirement.

St John Ambulance, Cefn Cribbwr division cadet camp at Wig Fach, Porthcawl in 1938, with cadets V. Morgan and J. Grabham as 'head cook and bottle washer'. The inauguration of the Cefn Cribbwr St John Ambulance division, as part of the Aberavon Corps, took place in May 1913 when the first ever minutes were recorded at a meeting held in the vestry of Nebo Baptist Chapel. A committee was formed and a swift start was made with first aid certificates being presented the following month at a local social function. In 1914, a first aid box was placed in front of the Cefn Cribbwr Workman's Institute and about the same time, a haversack and stretcher were purchased. Following the First World War, enthusiasm waned. However, unrest in the collieries in the 1920s served to draw members together again. In 1926 the ambulance cadet

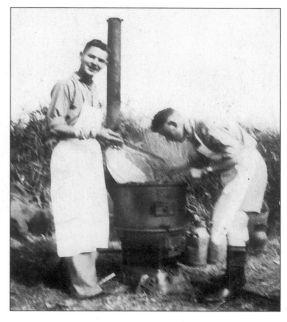

division was formed with Sergeant Rees T. Davies as its instructor. The examination report for this year showed that 18 men and 15 ambulance cadets had passed the examination. In July 1926, uniforms were purchased whilst the committee decided in 1927 to lease ground from the Dunraven Estate in order to build an ambulance hall. Ebley's Theatre in Cwmavon was purchased and the building re-erected in Cefn Cribwr in 1928. This served as the Ambulance Hall until 1938 when a new slate-roofed, brick-built hall was opened.

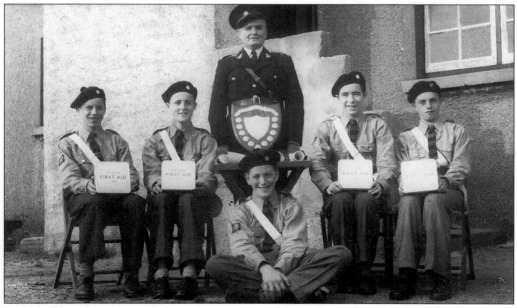

Cefn Cribbwr St John Ambulance division, Treorchy camp, 1956. From left to right: Gerald Davis, Lyn David, D. Teifi Davies (Ambulance Cadet Superintendent), Brian Langdon, Holford Stanton. Seated: Peter Jenkins.

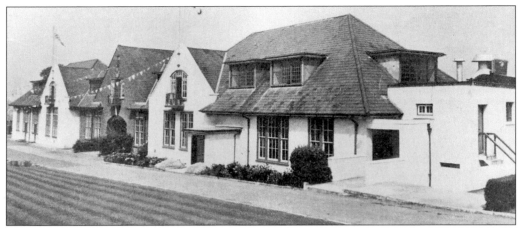

The Kenfig Hill & Pyle Welfare Institute, 1954, celebrating thirty years of achievement. The Kenfig Hill & Pyle Welfare Association (Miners' Welfare), was founded in May 1924, in connection with the local colliery undertakings of Baldwins Ltd. These embraced Aberbaiden and Pentre collieries, Newlands Colliery, Cribbwr No. 3 Colliery (closed down in 1930), and Ton Phillip Colliery (closed in 1928). The Welfare Institute was built at a cost of £12,000 on five acres of freehold land that had been bought and presented to the association by Baldwins Ltd. The opening ceremony took place on 18 August 1928. 'The Welfare', as it came to be commonly known, provided excellent facilities for social, cultural and recreational pursuits and transformed the social life of the community. There was a 'Welfare' cinema, a 'Welfare' dance hall, a 'Welfare' library, a 'Welfare' bowling green, 'Welfare' tennis courts, a 'Welfare' billiards hall, a 'Welfare' draughts club, and a variety of 'Welfare' guilds and societies. There was, and probably still is, a 'Welfare' bus stop. The building still serves the community today as a leisure centre thus remaining a lasting tribute to the efforts of all those miners and others who contributed to its establishment in the 1920s.

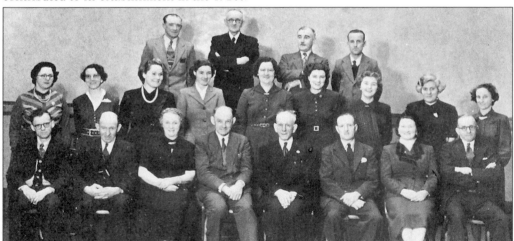

The staff of the 'Welfare', Pyle, 1954. From left to right, front row: Mr H. Tapp, Mr I. Davies, Mrs K. Davies, Mr W.L. Granville (General Secretary), Mr W.A. Hill (Chairman), Mr W.V. Thomas (Financial Secretary), Miss M. Thomas, Mr W.D. Hughes. Second Row: Mrs C. Morgan, Mrs L. Mitchell, Mrs M. Rogers, Mrs E. Evans, Miss G. Thomas, Miss M. Williams, Miss D. Williams, Miss M. Jenkins, Mrs C. Rees. Back Row: Mr R. Williams, Mr A. Beatty, Mr T. Austin, Mr C. Moody.

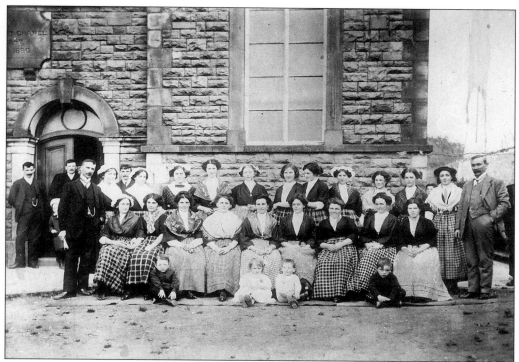

Elim Chapel Welsh costume tea, 1912.

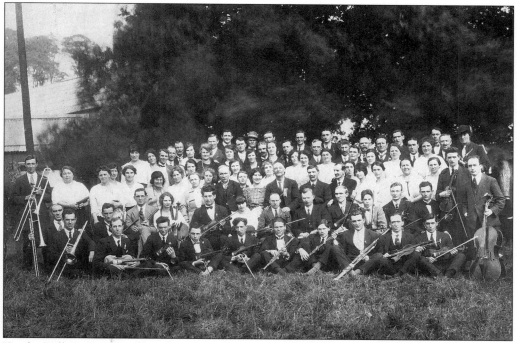

Kenfig Hill & District Choral and Orchestral Society, winners of a first prize at the Royal National Eisteddfod of Wales held at Pontypool, August 1924.

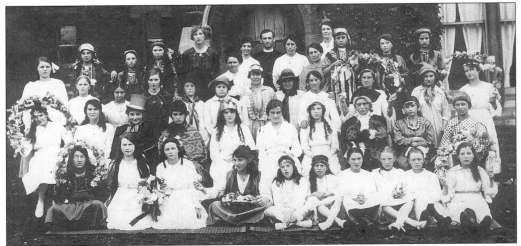

St Theodore's Church GFS (Girls Friendly Society), outside the vicarage, Kenfig Hill, in their costumes for the performance of the operetta *May Day in Welladay*. This was presented at the Cinema Hall, Kenfig Hill, on Tuesday 23 April 1918. It is not possible to identify all the cast present but Miss Lily Jones, fourth from the left in the front row, was the flower girl. In the second row, from left to right: -?-, -?-, Miss Gladys Cudmore (Granffer), Miss Sarah Evans, Miss Olive Cudmore (Annette, the new May Queen), Miss Beatrice Cudmore (the previous year's May Queen who organised the show), -?-, Miss Ruby Fortescue (who took the part of the beadle), Miss Bettie Jenkins (Fairy Rose) and Miss A. Chapman (Fairy Lily Bell). The curate-in-charge of St Theodore's Church, the Revd D. Eden Davies BA, is standing in the vicarage doorway.

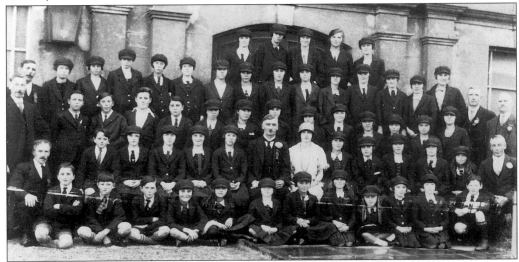

Kenfig Hill juvenile choir outside Moriah Chapel, 1926, prior to leaving to compete in the National Eisteddfod at Pwllheli where they would take second prize in their division. From left to right, front row: -?-, Dennis Marks, Thomas Edwards, Phyllis Brown, -?-, -?-, Katie Mort, Ceridwen Bassett, Eunice Evans, -?-, -?-, Glyn Edwards. Second row: -?-, Tom Jones, Kitty Hopkin, Doris Roach, Gwyneth Esaias, Doris Pring, Mr Esaias Esaias (conductor), Mrs Gwyneth Chess (née Davies) ALCM (accompanist), -?-, -?-, -?-, -?-, -?-, Mr J. Jenkins. Third row: -?-, Fred Fletch, Elwyn Jenkins, David Brown, Len Cook; remainder of names unknown.

Seven
Views and Scenery

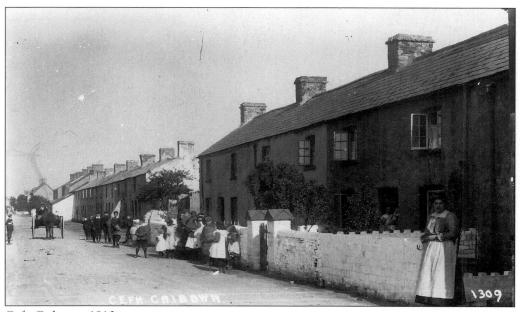

Cefn Cribwr, *c.*1910.

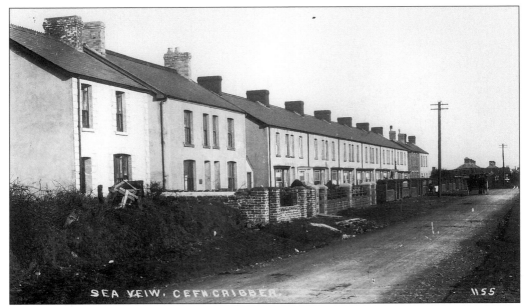

Sea View, Cefn Cribwr, c.1910.

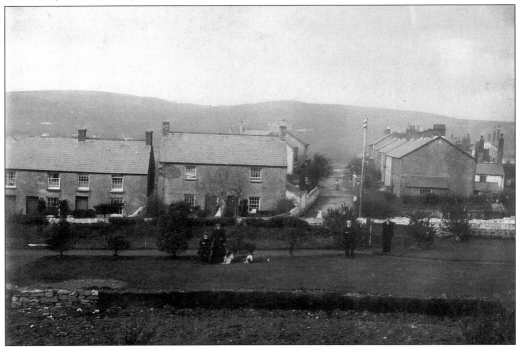

High Street and School Road, Kenfig Hill, as viewed from St Theodore's Church vicarage. The photograph was probably taken in 1909 when the extension to St Theodore's Church was formally opened. The gentleman sitting in the centre is presumably the Revd Alcwyn Saunders Jones BA, curate-in-charge, while the bearded gentleman near the gate could well be the Rt Revd Joshua Pritchard Hughes, Lord Bishop of Llandaff, who carried out the opening ceremony.

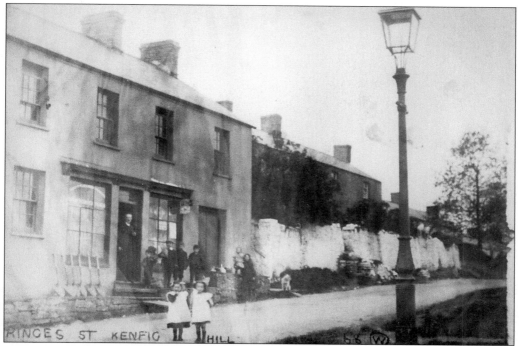

Princes Street, Kenfig Hill, early 1900s. This is now Victoria Road just behind the rear of the Woodstock Inn. The shop is on the corner near to where Elim Chapel once stood.

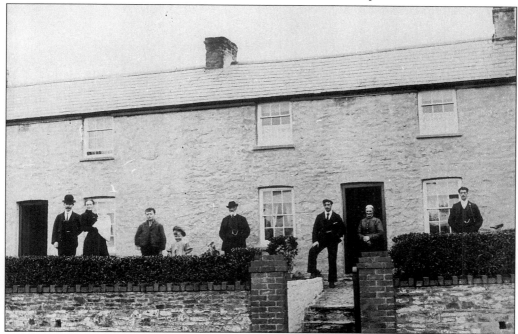

Victoria Road, Kenfig Hill, c.1906. A closer view of the cottages to the centre of the above photograph. From left to right: John Howells, Margaret Howells (holding baby Willy), James Howells, Eddy Howells, Esaias Esaias Snr., Esaias Esaias Jnr., Katherine Esaias, James Esaias.

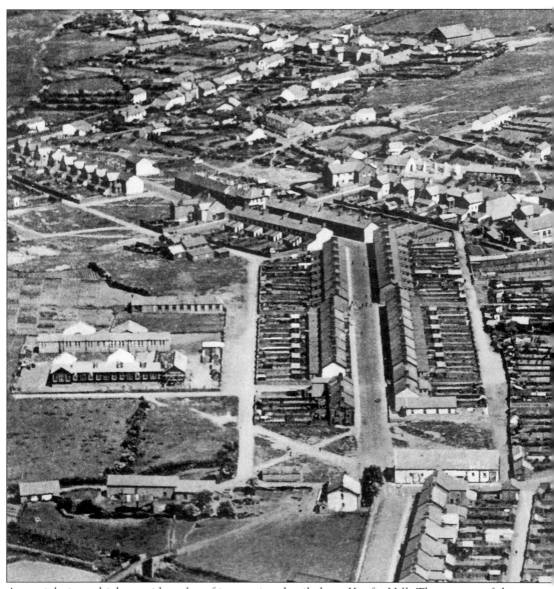

An aerial view which provides a lot of interesting detail about Kenfig Hill. The reverse of this giant photo-card bears the rubber stamp of R.E. Bradley, No. 1 Evans Street, Kenfig Hill, Glam., Newsagent Etc. & General Dealer. Mr Bradley was responsible for commissioning and selling a whole series of postcard views of Kenfig Hill and the surrounding district in the early 1900s. The negatives for these postcards were on glass plates – the photographic procedure used at the time; some of the images that appear in this book have in fact been reprinted from such plates prior to publishing. With a little bit of detective work, we can date the above image quite precisely. There are a number of structures in Kenfig Hill which provide clues to help with the dating. For example, St Theodore's Church, on the hill to the top right of the photograph, was built in 1889 and had its extension added in 1909. Moriah Chapel further down the road was erected in 1850. In Margam Row, we see the first St Theodore's Church Hall which was officially opened on 11 October 1922. The War Memorial is absent from the Top Cross; this

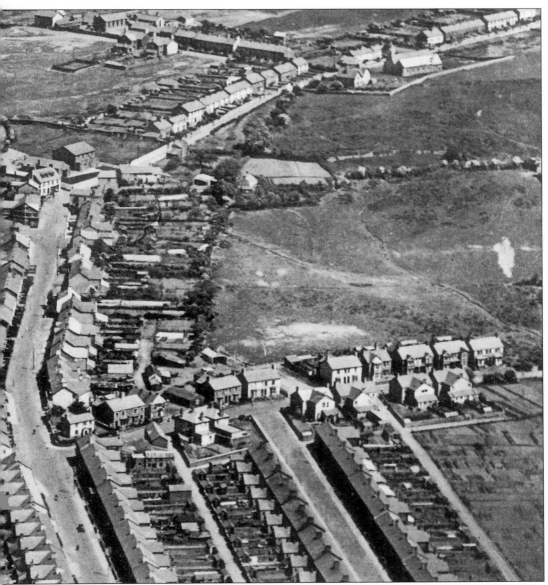

was not dedicated until 11 November 1925. The 'Old Tin School' on the left, was erected before 1913 as shown by other dated photographs (it burnt down in 1942), while the Ambulance Hall, just above the school, was constructed in 1914 (demolished in the late 1970s). The Gaiety Cinema was opened on 12 September 1913 and Bethel Mission in Pwllygarth Street (just above the Gaiety), was built in 1920. Along Waunbant Road, we have the police station which bears the date 1911 firmly inscribed in stone on its façade. The first St David's Presbyterian Church was built in 1909, but the new St David's Church has yet to be erected (it was subsequently built in 1928). As we proceed further along this road, we also find that the new houses have yet to be built. These were constructed in 1926. From the above information, the opening of St Theodore's Church Hall and the unveiling of the War Memorial provide the two most decisive clues. These enable us to narrow down a date for the photograph to between 1922 and 1925.

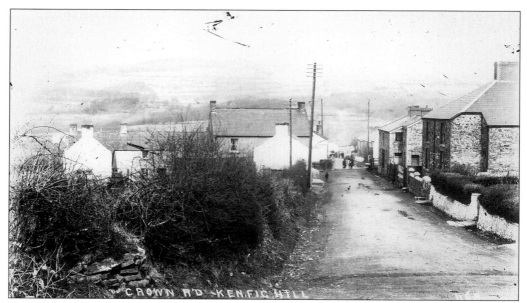

Crown Road, Kenfig Hill, *c*.1910.

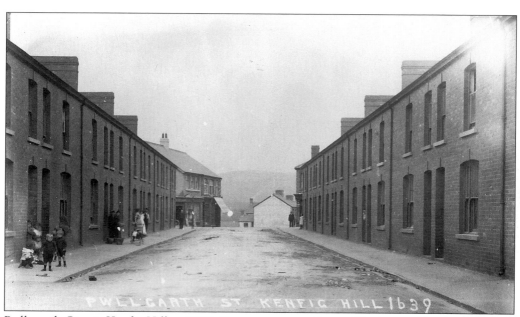

Pwllygarth Street, Kenfig Hill, *c*.1910. Two youngsters, Trevor Hopkin and his brother Ken, are standing outside the house to the left.

Moriah Place (Top Cross), Kenfig Hill, with Moriah Chapel in the background, early 1900s.

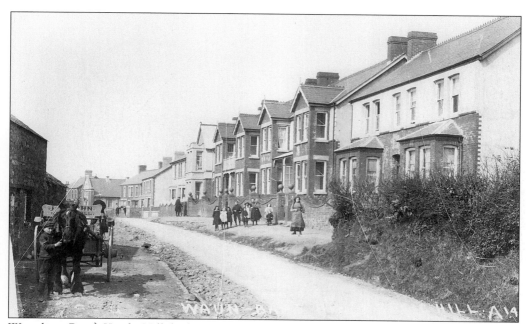

Waunbant Road, Kenfig Hill, looking towards St David's Presbyterian Church, which was built in 1909.

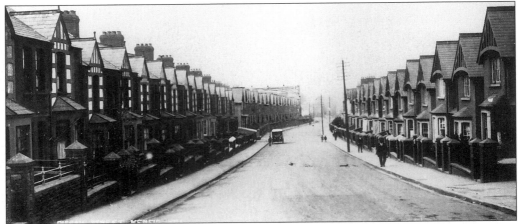

Pisgah Street, Kenfig Hill, *c*.1910, looking down the hill towards Pisgah Chapel in the distance.

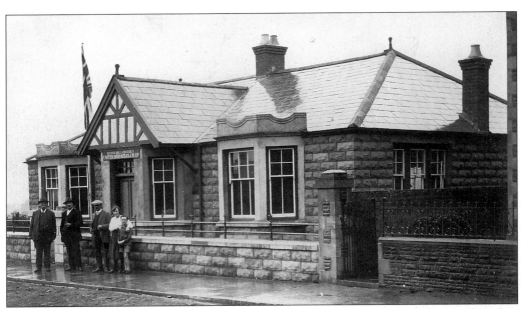

The United Services Club, No. 88 Pisgah Street, Kenfig Hill, 1920s. This building used to house the First World War memorial plaque to the fallen. Most will remember it as the Radio Rentals building with the eerie blue glow that used to be given off by the mercury arc rectifiers inside. The premises is now the surgery of David Barrie the dentist.

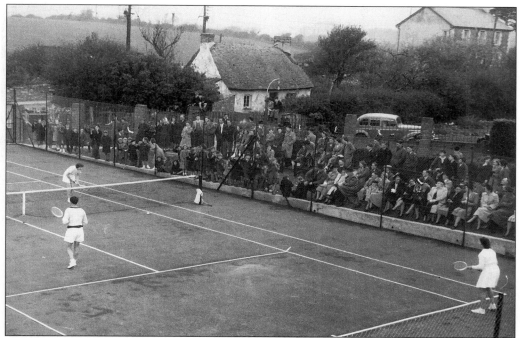

Opening of the new tennis court and ornamental garden at the Kenfig Hill and Pyle Welfare Institute, Saturday 5 May 1951. Note the thatched cottage in the background. This, together with a garden and orchard, was owned by a Mr Griffiths who used to let his geese range free causing many to give the area a wide berth.

The Cross at Pyle, c.1905. This is a deceptive view as the main road to Kenfig Hill curved to the left behind the wall in the centre of the photograph. Ffald Cottages can be clearly identified behind the lady and young girl standing in the centre.

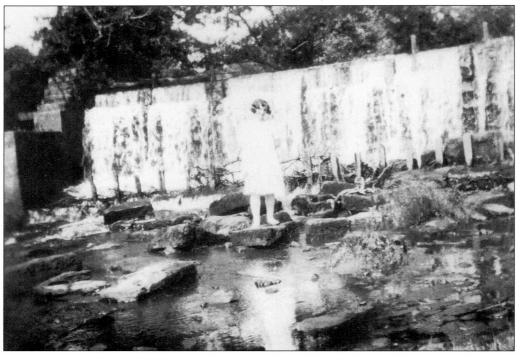

A young Mrs Janet Davies (née Waite) posing in front of the Collwyn Falls, Pyle, in the 1920s.

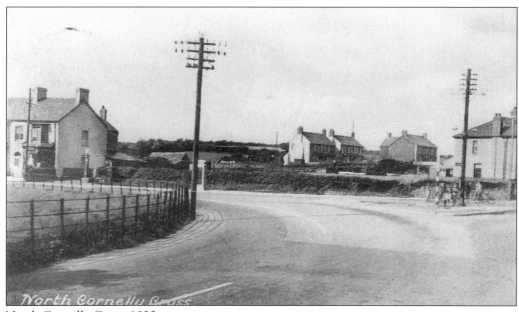

North Cornelly Cross, 1930s.

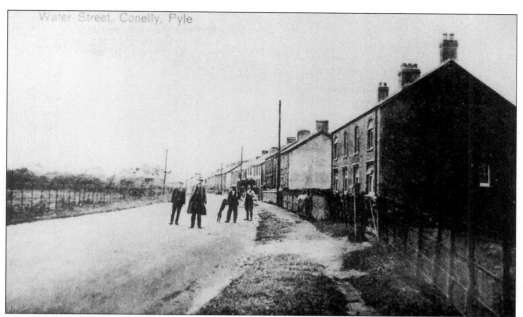

Water Street, Cornelly, *c.*1910.

Mawdlam village in the 1920s.

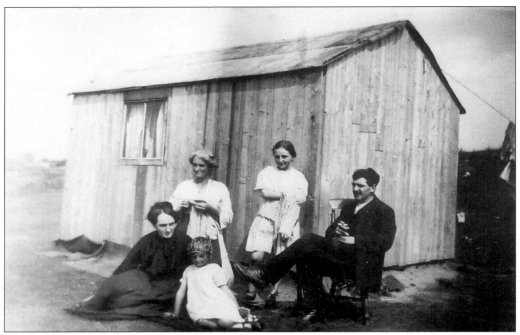

An example of one of the summer holiday huts at Kenfig, 1920s.

Ton Kenfig in the inter-war years.

Nine
Events

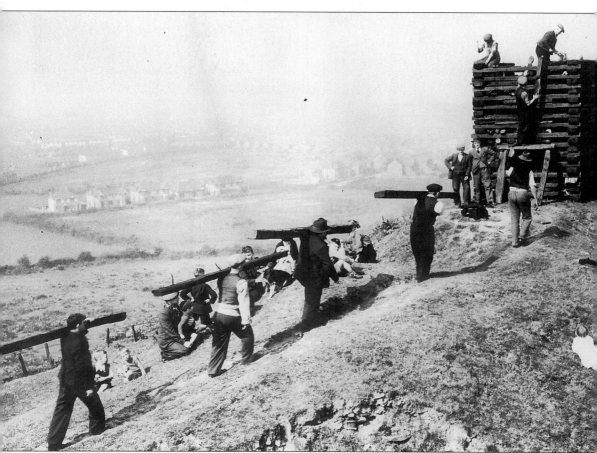

The bonfire built on the Ton, Kenfig Hill, for the coronation of King George VI on 12 May 1937. According to the newspaper article that accompanied the photograph, the beacon would be seen in seven counties: Devon, Somerset, Gloucestershire, Breconshire, Carmarthenshire, Monmouthshire and Glamorgan.

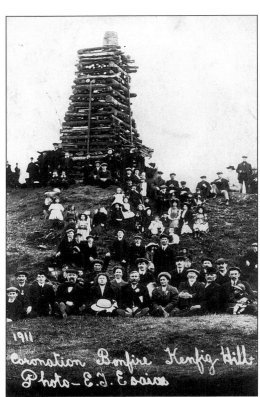

Bonfire on the Ton, Kenfig Hill, for the coronation of King George V, 22 June 1911.

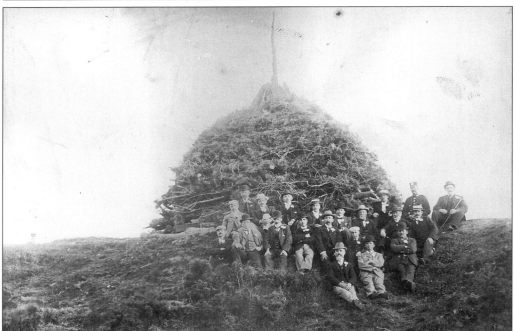

Bonfire constructed at Kenfig, probably to celebrate the 1911 coronation of King George V judging by the pill-box style, peaked cap worn by the police constable.

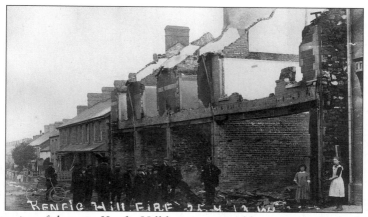

The gutted remains of shops in Kenfig Hill being surveyed by a group of onlookers and Police Sergeant Morgan following the disastrous fire of 25 July 1913. As reported in the local press at the time, on Friday evening, Kenfig Hill was the scene of a tremendous conflagration which resulted in the destruction of four commodious business premises situated on Bowen's Cross. The fire originated in the premises of Mr Ivor Parker, the draper, as a result of the falling of a large Blanchard petrol lamp that had been hung in his shop window. The fire quickly spread through the shop and within a few minutes the whole building was ablaze. In a short time, and before it could be contained, the fire had engulfed and destroyed the establishments of Mr Herbert Jones, the chemist, Mr Fred Love, the tobacconist and hairdresser, and finally the boot and shoe shop of Mr Evans. The fire was prevented from spreading to the adjacent houses in the street, but the heat was so intense that it cracked and broke the windows of the post office on the other side of the road. Soon after the outbreak, the Bridgend Fire Bigade was sent for and it arrived within half an hour of the alarm being given. Not bad for a horse drawn fire tender which was reported to have 'rattled up Park Street [Bridgend] at a good pace'. Unfortunately, when it arrived at Bowen's Cross, Kenfig Hill, there was no water available there to fight the blaze. The nearest fire hydrant was in Waunbant Road and that had been metalled over. The final assessment of the damage caused was £8,000, this being the third severe fire that had occurred in Kenfig Hill during the previous twelve months. The problem had been recognised, however, and on 31 October 1913, Penybont Rural District Council resolved to fix sixteen fire hydrants in the Kenfig Hill district.

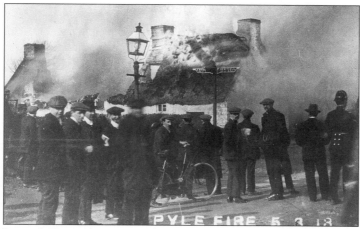

Blaze at Pyle Cross, 5 September 1913. The cottage on fire stood approximately on the spot now occupied by the car park in front of First Choice.

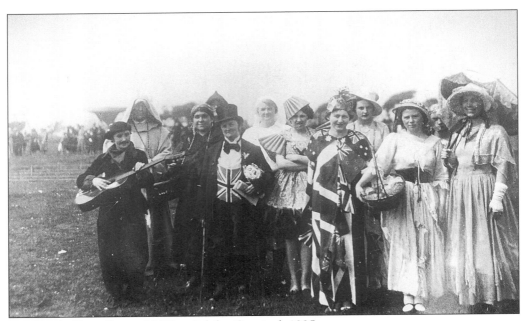

Ton Kenfig King George V Silver Jubilee Carnival, 1935.

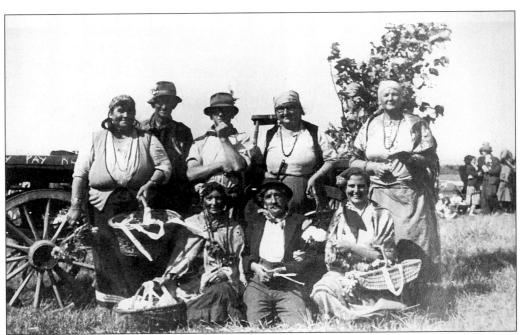

Ton Kenfig King George V Silver Jubilee Carnival, 1935.

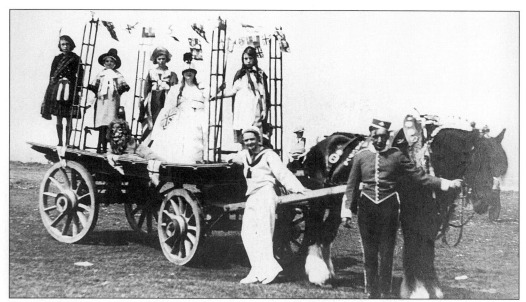

Ton Kenfig King George VI Coronation Carnival, 9 May 1937.

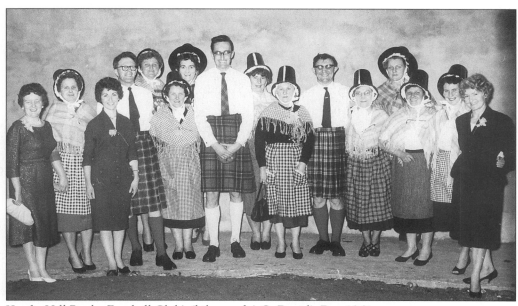

Kenfig Hill Rugby Football Club's 'kilt parade', St David's Day 1961.

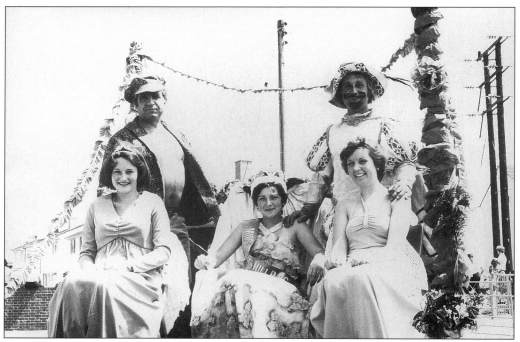

Kenfig Hill Carnival, June 1976.

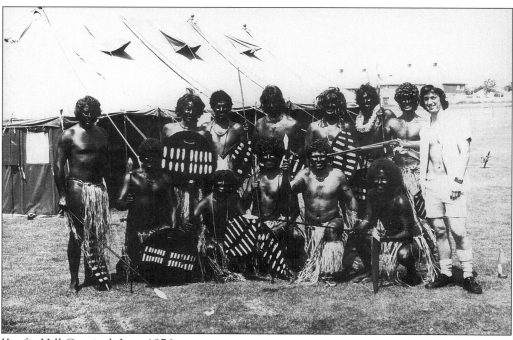

Kenfig Hill Carnival, June 1976.

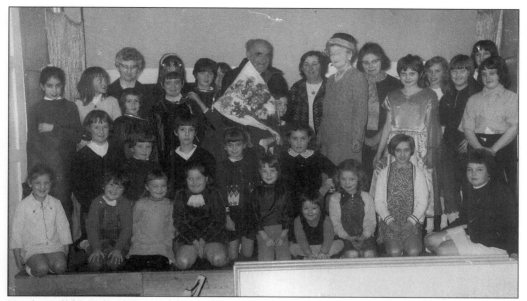

Kenfig Hill branch of the Girls Friendly Society celebrating their fiftieth anniversary in 1968, with the vicar, the Revd David Jones-Davies, MA, presenting a bouquet of flowers to Miss Queenie Phillips. The GFS was started in Kenfig Hill in 1918 by Mrs Eden Davies, the wife of the then curate-in-charge of St Theodore's Church.

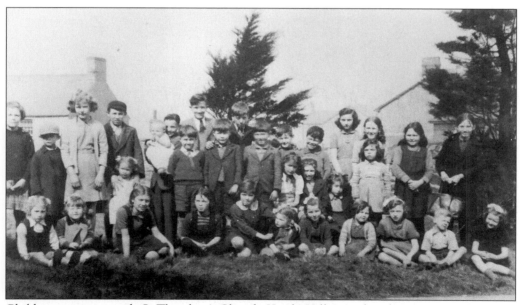

Children waiting outside St Theodore's Church, Kenfig Hill, to gather the pennies traditionally thrown after a wedding, 1940s.

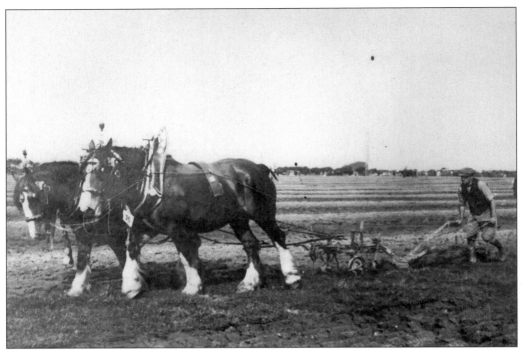

David Rees Thomas of Pencastell Farm, at ploughing trials in the 1960s.

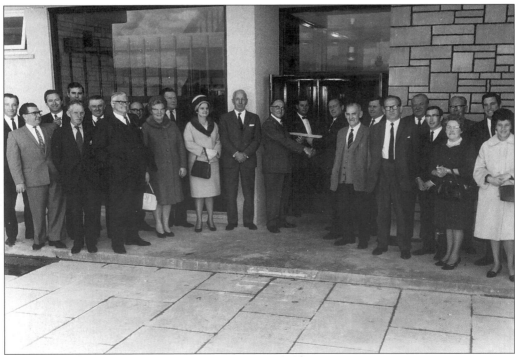

County Councillor Edwin T. Davies, CBE, JP, opening the Pondarosa Social and Athletic Club Limited, North Cornelly, 1966.

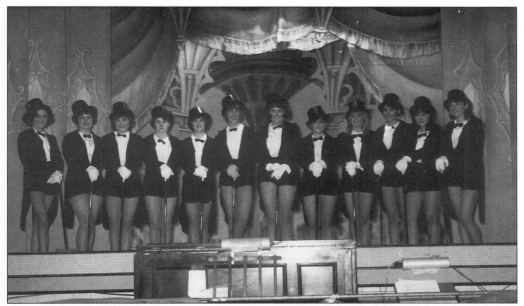

The Cefn Cribwr 'Tiller Girls' lining up for their performance in the pantomime *Mother Goose* at the Cefn Cribwr Community Hall, 1970s.

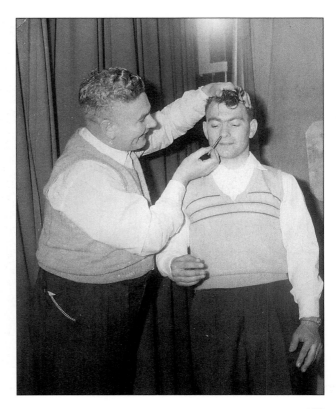

Backstage preparing for a drama presentation at Cefn Cribwr Community Hall in the 1970s. The stage manager and make-up artist is Mr Teifi Davies of Cefn Cribwr.

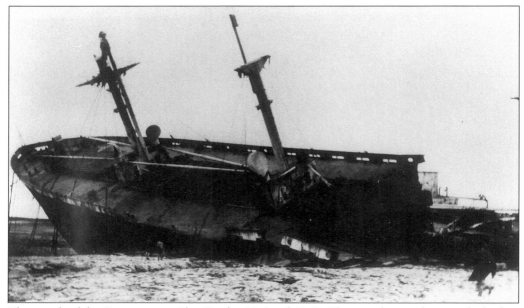

The wreck of the *Samtampa* on Sker Rocks, 23 April 1947. The vessel went down with the loss of all hands. The Mumbles lifeboat, the *Edward, Prince of Wales*, which went to the rescue, overturned in the treacherous seas and all the crew were drowned.

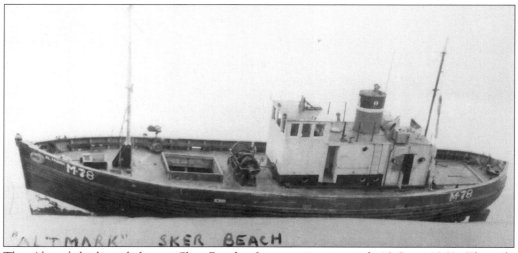

The *Altmark* high and dry on Sker Beach after running aground, 12 June 1960. The sole crewman was rescued and assisted ashore by the Porthcawl life saving crew.

Ten

The War Years

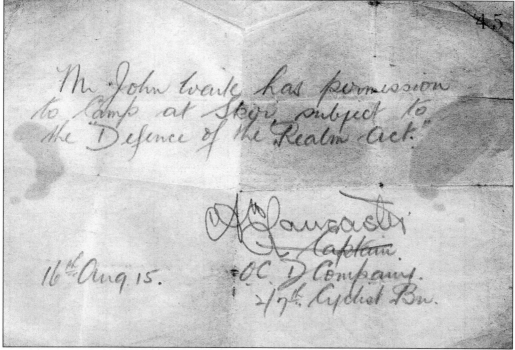

Permit given to Mr John Waite allowing him to camp at Sker during the First World War. It is signed by Captain A. Lancaster, Commanding Officer, 'D' Company of the 217th Cyclist Brigade. When camping on the burrows during this period, the tents had to be located behind the sand dunes so that their fires and lamps would not be visible to a potential enemy vessel in the Bristol Channel.

WITH THE COMPLIMENTS OF THE
Inhabitants of Kenfig Hill and the Kenfig Hill Cinema.

Being part of the proceeds of a Concert held at the Cinema on March 3rd, 1915, for the Benefit of the Kenfig Hill Boys serving with H.M.F.

Committee : Sergt. MORGAN, Messrs. J. DAVIES, Clothier, IVOR PARKER, Draper, and EVAN HARRIS, Dentist.

Secretary, G. Pegley. Treasurer, B. A. Brokensha.

Admission card for a concert held in the Gaiety Cinema, Kenfig Hill on 3 March 1915. The proceeds of the event were used for the benefit of the Kenfig Hill men serving with His Majesty's Forces.

'Terriers' marching from their camp at Ty Coch across the golf course and Kenfig sand dunes, between the wars.

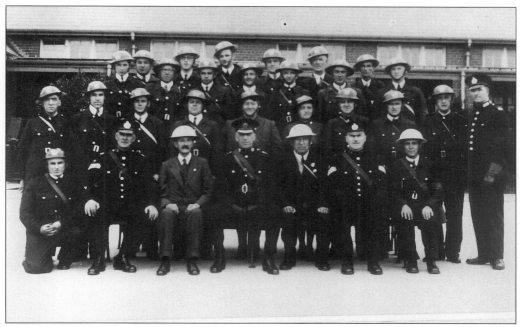

Pyle & Kenfig Hill District police and air raid wardens at the Pyle warden's post, during the Second World War.

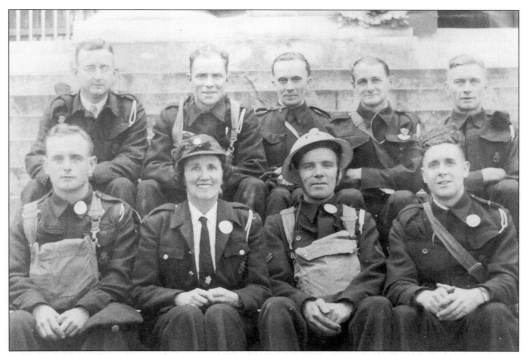

Pyle air raid wardens during the Second World War. From right to left, front row: I. Flower, Mrs Charles, R. Verrall, J. Hier. Back row: H. David, G. Verrall, P. Dixon, R. Tyler, J. Jenkins.

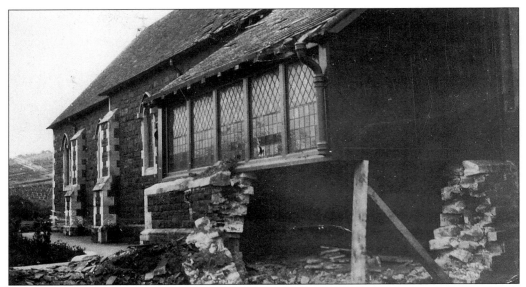

'Church Wrecked by Bomb Blast. Blast from bomb caused this damage to a church in South Wales.' This was the caption that accompanied a similar photograph published by the wartime press. There were, of course, restrictions in operation that prevented the newspaper naming the church, but everyone locally knew that it was St Theodore's Church, Kenfig Hill. On Sunday, 4 May 1941, just after midnight, seven bombs were dropped: one in Cound's garden, two in Biddle's garden, one by the church porch doing much damage to the church, another which severely damaged the east wall of the church, another in Nibblet's allotment and the other further up near the house occupied by Mr Evan Thomas. There was also a large bomb which failed to detonate on impact. This was destroyed a few days later by a bomb disposal squad using a controlled explosion which nevertheless caused even more damage by blowing out windows and doors. The type of bomb was possibly a German SC 250kg high explosive bomb which had four small incendiaries attached to the fins. These incendiaries were meant to detach during the flight down causing separate damage and fires.

NATIONAL
REGISTRATION

IDENTITY
CARD

National Registration identity card dated 17 June 1943.

**To the people of the Soviet Union from the people of Great Britain
in commemoration of Stalingrad**

**Советскому Народу от Народа Великобритании
в Ознаменование Защиты Сталинграда**

From Kenfig Hill Council for British-Soviet Unity

**От Комитета Британско-Советского Единения,
Кенфиг-Гилл**

One Bed Одна Кровать

*To the brave people of Stalingrad from the people
of Kenfig Hill*

*Доблестным жителям Сталинграда от жителей
Кенфиг-Гилл*

**This page records the gift of equipment in the
City Clinical Hospital, Stalingrad**

**Эта страница отмечает дар нижеследующего оборудования
Городской Клинической Больнице Сталинграда**

Herbert Johnson
CHAIRMAN
ПРЕДСЕДАТЕЛЬ

F. Gousev

P. Chalmers Mitchell
TREASURER
КАЗНАЧЕЙ

HIS EXCELLENCY THE SOVIET
AMBASSADOR
ЧРЕЗВЫЧАЙНЫЙ И ПОЛНОМОЧНЫЙ
ПОСОЛ СССР В ВЕЛИКОБРИТАНИИ

JOINT COMMITTEE FOR SOVIET AID
ОБЪЕДИНЁННЫЙ КОМИТЕТ
ПОМОЩИ СОВЕТСКОЙ РОССИИ

The Stalingrad Hospital Fund. In 1943, the Joint Committee for Soviet Aid opened a fund 'to enable the British people to express in a concrete and practical way their deep feeling towards the heroic citizens of Stalingrad and the victorious Red Army men'. A target of £75,000 was set to enable a new hospital to be built in Stalingrad (now Volgagrad). The appeal was an overwhelming success as over three times the amount asked for was raised. It was intended that plaques be fixed on the wall giving the names of donors who had endowed a bed or ward. However, on the request of the Soviets, a commemorative album was produced instead giving the names of donors and their messages to the people of Stalingrad. The above page records the gift of a bed made by the people of Kenfig Hill to the City Clinical Hospital, Stalingrad. Mr C. Reynolds of Pwll-y-Garth Street, was responsible for organising the collection for the fund in Kenfig Hill. During the same period, Churchill presented a ceremonial sword to the people of Stalingrad on behalf of the people of Great Britain.

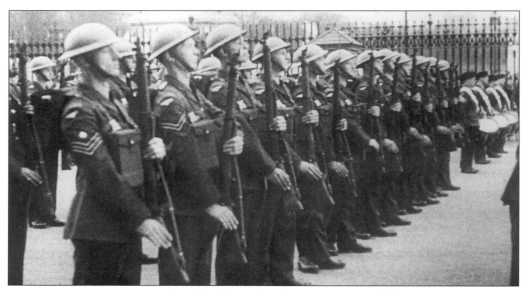

As part of the celebrations to mark the 25th anniversary of its founding, the RAF (Royal Air Force) was invited to mount guard at Buckingham and St James' palaces for four days from 1 April 1943. The late Mr Aneurin Griffiths of Waunbant Road, had the distinction of being the flight sergeant in charge of the RAF regimental guard mounted on this occasion. The guard of honour was inspected by King George VI during the celebration parade. Aneurin made the headlines with pictures in the London newspapers showing him (nearest to camera) at the head of his squad.

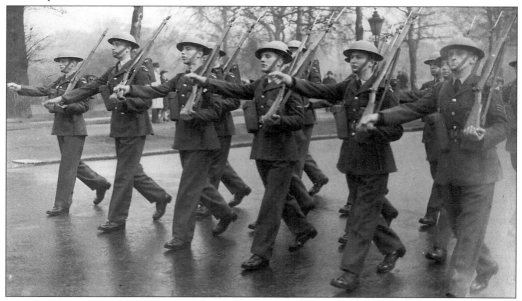

The RAF Regiment King's Guard drilling in London on 25 March 1943 when they were inspected by Air Marshall Sir Arthur Barratt, Chief of Army Co-operation Command. The precision drill work that Aneurin (far left) had an active part in developing as a instructor, was the beginning of the formation drill work that we have come to expect of the RAF Regiment at displays ever since.

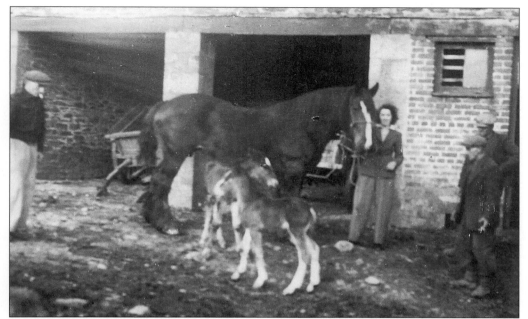

'Helping the War Effort – Twin Colts for Welsh Farm [Pencastell Farm, Kenfig Hill]'. As reported by the *Reynolds News* correspondent at the time: 'Although Violet knew she was about to become a mother, she also realised the importance to the national effort of her land job, so she kept hard at work on the farm near Bridgend right up until three days before her happy event took place. When that happy day arrived, it was – twins! The story is remarkable because "Violet" is a six-year old Shire mare, and it is a rare occurrence for twin colts to survive. Violet gave birth to twins in an open field, entirely unaided. There had been no suspicion that twins were on the way.'

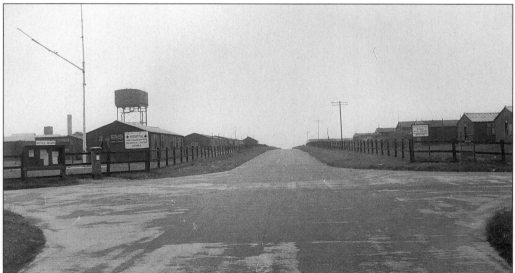

A demilitarised Stormy Down aerodrome on 11 June 1948 just after it was taken over by the Steel Company of Wales as a hostel for the contractors building the new Abbey Works at Port Talbot.

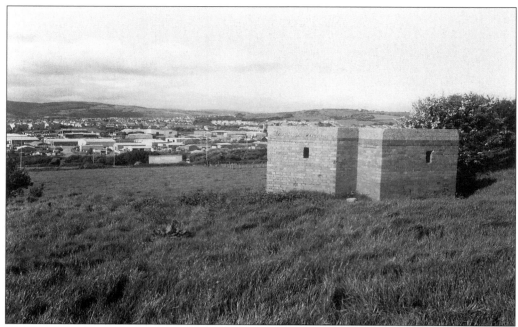

The legacy of war. The remains of a pill box in a commanding position overlooking the A48 main road crossing Stormy Down and what was Pyle railway station.

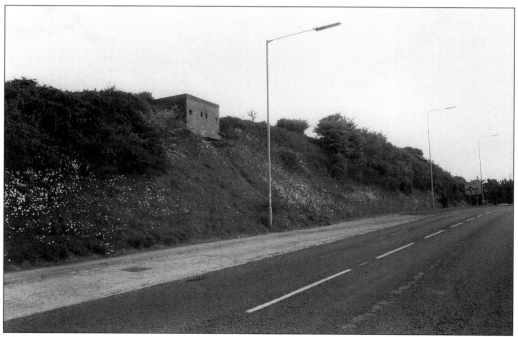

The remains of a second pill box at Pyle perched overlooking the road leading to North Cornelly Cross on one side and the railway line to Porthcawl on the other.

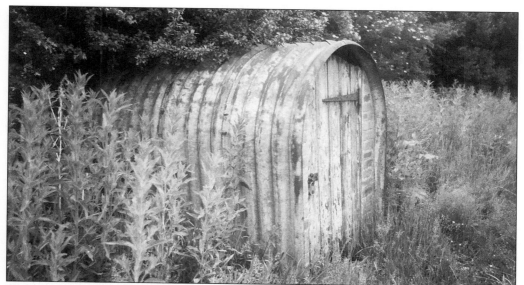

The remains of an Anderson shelter in a field at Mawdlam. As part of air raid precautions during the war, these were issued in kit form for construction in the gardens of houses. The sides were formed of curved corrugated sheets which overlapped at the top; straight corrugated sheets were used for the front and back with an opening to form an entrance. The shelter was intended to be part buried in a suitably deep hole with earth thrown over the top to provide further protection. After the war, these shelters were readily converted into garden and allotment sheds once you succeeded in loosening the bolts that held the corrugated sheets together. Usually, only the curved sections have survived.

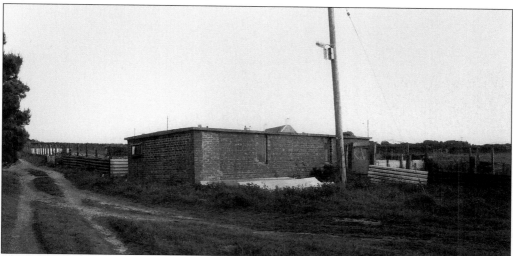

The remains of a communal shelter at Kenfig. These were constructed of brick and had a flat concrete roof almost a foot thick. Other types of communal shelter were constructed by Glamorgan County Council in the summer of 1938 as part of air raid precautions. These consisted of pits dug in the ground which were to be roofed over with steel beams and covered with sand bags. Trenches were excavated at Collwyn Road, Pyle, and opposite Bryndu School, Kenfig Hill, but were abandoned following Chamberlain's return from Berlin where short-lived assurances of Germany's 'peaceful' intentions had been secured from Hitler.

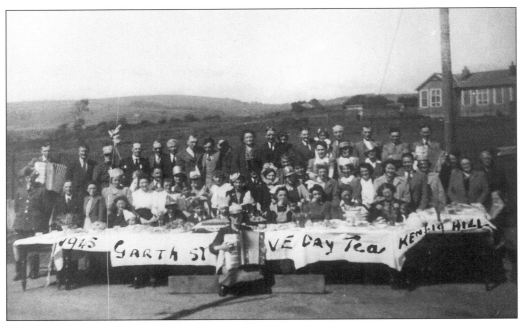

VE Day tea party in Garth Street, Kenfig Hill, 1945.

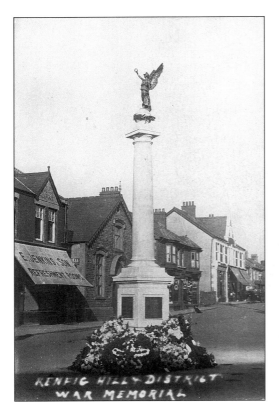

The War Memorial at the Top Cross, Kenfig Hill which was unveiled on 11 November 1925 by Major-General Sir T.O. Marden. This was at a time when Armistice Day was celebrated on 11 November each year no matter what the day and everyone and everything stopped for two minutes silence at 11 a.m. precisely.

Eleven
Recreation and Sport

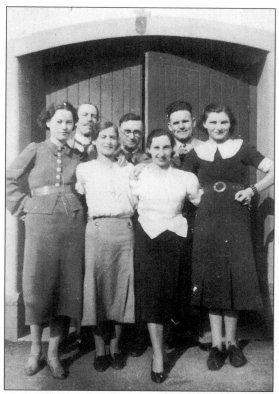

The staff of the Gaiety Cinema, Kenfig Hill, 1920s. From left to right: Doreen Thomas, Mr Wilson (projectionist), Dulcie Evans, Merlin Fabian, Cassie White, Dave Park, Enid Endicote. The *Glamorgan Gazette* of 12 September 1913 reported that the opening of the cinema marked a new era for Kenfig Hill amusement seekers.

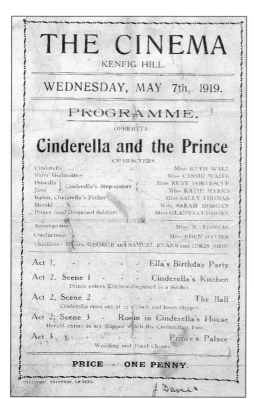

THE CINEMA

KENFIG HILL.

WEDNESDAY, MAY 7th, 1919.

PROGRAMME.

OPERETTA—

Cinderella and the Prince

CHARACTERS.

Cinderella Miss RUTH WALL
Fairy Godmother Miss CASSIE WAITE
Priscilla } Cinderella's Step-sisters { Miss RUBY FORTESCUE
Jane } { Miss KATIE MARKS
Baron, Cinderella's Father Miss SALLY THOMAS
Herald Miss SARAH MORGAN
Prince (and Disguised Soldier)	Miss GLADYS CUDMORE

Accompanist Miss N. THOMAS
Conductress Mrs. EDEN DAVIES
Violinists Messrs. GEORGE and SAMUEL EVANS and IDRIS JOHN	

Act 1, - - - - - Ella's Birthday Party

Act 2, Scene 1 - - - Cinderella's Kitchen
Prince enters Kitchen disguised as a Soldier.

Act 2, Scene 2 - - - - - The Ball
Cinderella runs out at 12 o'clock and loses Slipper.

Act 2, Scene 3 - Room in Cinderella's House
Herald enters to try Slipper which fits Cinderella's Foot.

Act 3 - - - - - Prince's Palace
Wedding and Final Chorus.

PRICE - ONE PENNY.

WILLSONS', PRINTERS, LEICESTER.

Programme for the performance of *Cinderella and the Prince* at the Cinema, Kenfig Hill, 1919.

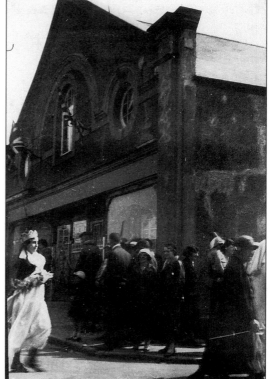

The Gaiety Cinema, Kenfig Hill, 1930s.

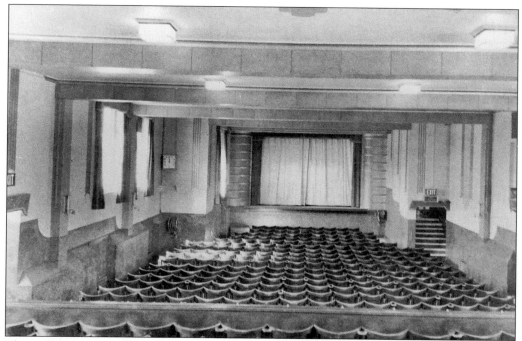

The well-appointed cinema in the Kenfig Hill and Pyle Welfare Institute, 1954. The cinema, with its 'upstairs' could seat an audience of 450. Mr Graham John of Ton Kenfig recalls that when children's matinées started in 1932 each child attending the first performance was given a shiny new penny and an orange.

The cinema at Stormy Down, 11 June 1948. It was housed in what had been the RAF camp gymnasium.

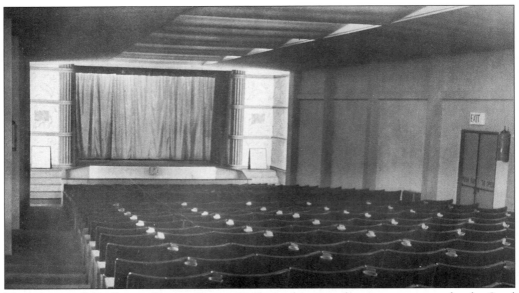

The interior of the Stormy Down cinema, 1947. At this time the cinema was run by the Steel Company of Wales as part of their hostel here. Managed by Mr Don Twine, the cinema was equipped with a modern Gaumont-Kalee cine projector and was capable of holding an audience of four hundred. Film shows were initially held every Tuesday and Thursday and by June 1951 on Sundays as well.

GAIETY
KENFIG HILL
Week Commencing June 4.

Mon., Tues., Wed.

Gregory Peck, Helen Westcott

'THE GUNFIGHTER'
Also (U)
"IT HAPPENS EVERY SPRING"

Thurs., Fri., Sat.
Barry Jones, Andre Morell, Olive Sloane in

"SEVEN DAYS TO NOON"
(A)
Also
'NIGHT TIME IN NEVADA'

Sunday, June 3.
George Raft, Brenda Marshall in
"BACKGROUND TO DANGER" (A)
Also "OVER THE WALL" (U)

Welfare Cinema, -:- Pyle -:-
Week Commencing Monday, June 4.
Mon., Tues., Wed.
GLENN FORD, VALLI, CLAUD RAINS

'THE WHITE TOWER
Victor Mature, Lucille Ball
" EASY LIVING "

Thurs., Fri., Sat.
LISA DANIELLY, HUGH McDERMOTT

"LILLI MARLENE"
James Ellison, Virginia Herrick
"I KILLED GERONIMO"

Sunday, June 3.
Susan Peters, Alex Knox
"SIGN OF THE RAM"
Virginia Grey "NIGHT CLUB GIRL"

Tues., Weds & Frid. commencing 6 30 p.m.
Mon., Thurs. & Sat. continuous from 4.45 p.m.

The films that were showing at the Gaiety and Welfare cinemas on 1 June 1951.

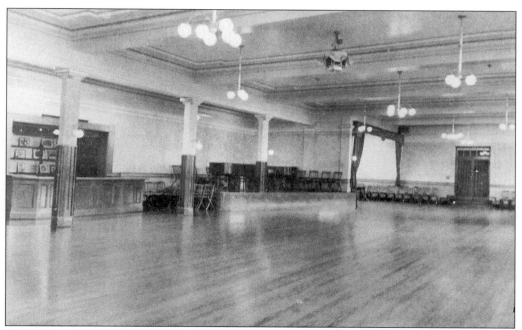

The ballroom at the Kenfig Hill and Pyle Welfare Institute, 1954.

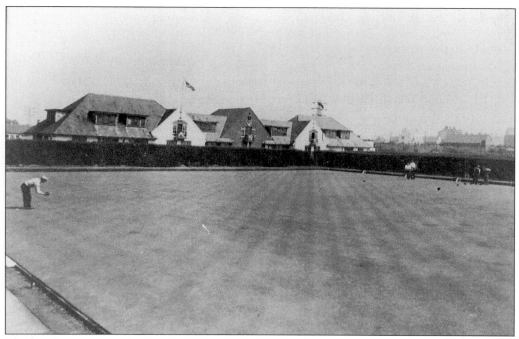

The bowling green at the Kenfig Hill and Pyle Welfare Institute, 1954.

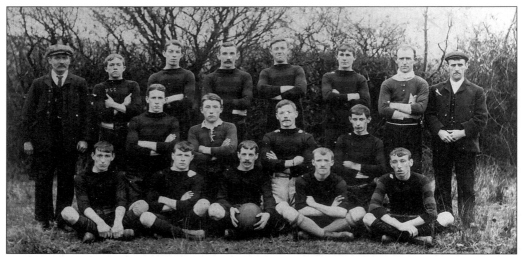

Kenfig Hill Coronation Stars RFC, 1905-06 season. From left to right, back row: J. Cooke (referee), W. Cooke, I.J. Stubbs, R. James, W. Williams, J. Thomas, Revd A. Jones, Rees John (touch judge). Second row: F. Lewis, D. Price, D. Evans, W. Powell. Front Row: H. Richards, T. Davies, E. Leyshon (captain), W.E. Williams, J. Baker.

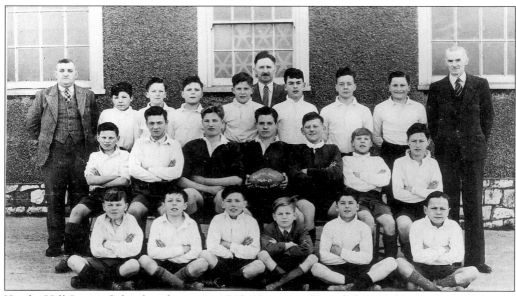

Kenfig Hill Junior School rugby team, 1948-49 season. From left to right, front row: Morton Jones, Arthur Griffiths, Gwyn Griffiths, Terry Hodge, Wynne Morgan, Clifford Jenkins. Second row: Brian Hopkins, Norman Lewis, John Dodd, Sidney Davies (captain), Rowland Hawkins, Warren Pugh, Alan John. Back row: Mr Gwyn Davies, Jim Barnett, Douglas Peers, Mervyn Ralphs, Wyndham Evans, Mr David Phillips (headmaster), Malcom Evans, Gerry Grey, Desmond Harman, Mr Stanley Lewis.

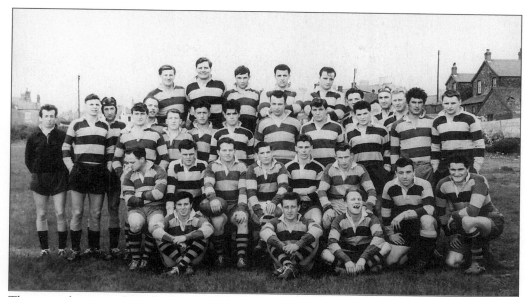

The team that turned out for Kenfig Hill RFC in the match against Cardiff Athletic, 29 April 1959.

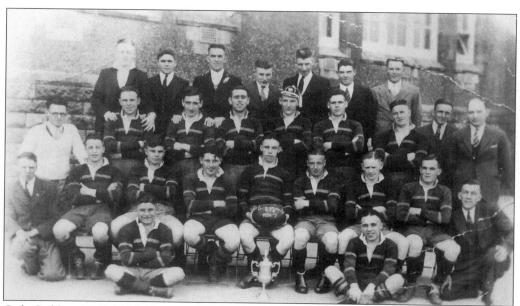

Cefn Cribbwr RFC, 1936-37 season.

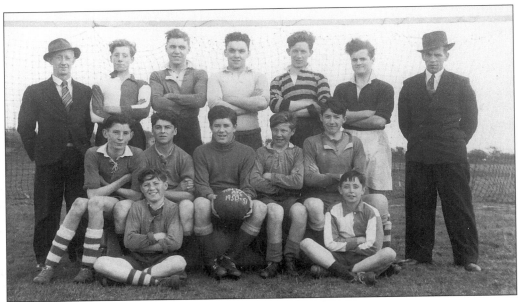

Kenfig Hill High Street football team, the 'Ton Boys', 1930s.

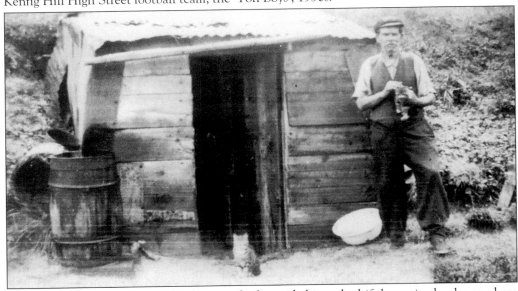

Ben the hermit of Kenfig Sands, photographed outside his makeshift home in the dunes where 'he made a full-time occupation out of leisure'. Called Ben Wild by some, he was referred to as a 'Welsh Robinson Crusoe' in a *South Wales Echo* interview published on Tuesday 10 April 1934. The story relates how Kenfig Hill born Ben Evans, a former colliery timberman, forsook civilisation and went to live in a dugout in the sand dunes of Kenfig. By 1934, he had been there for ten years living off his old age pension and the proceeds from selling drift-wood and fish. 'I have discovered that life is full of beautiful things and I am very happy', he once said. Ben was a real character but he had to endure much during his stay at Kenfig. On three occasions the local landowners burned down his dugout in a attempt to force him to move away. Illness finally brought an end to the solitary life of the ex-miner and during the Second World War he went to live with his sister in Penygraig in the Rhondda where he died.

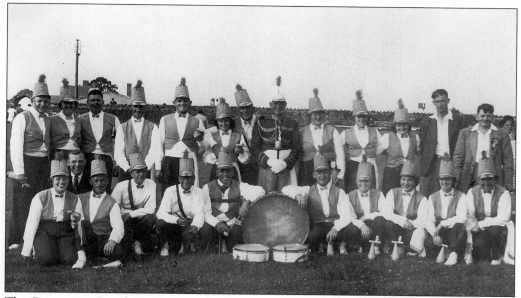

The Coronation Royal Paraders, Kenfig Hill, 1953. Among those pictured are: Frank Dunster, Selwyn Roberts, George Parks (centre).

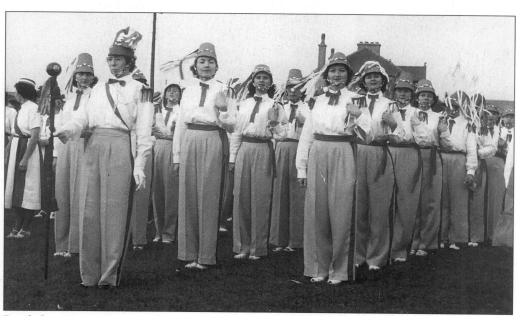

Bands from Evans Street and Picton Street during the Festival of Britain celebrations, 1951.

Officials from Aberbaiden Colliery on a river trip at Windsor in the 1930s.

En route to the camp site at Kenfig burrows in the 1920s. Have horse, will travel. Everything went including the proverbial 'kitchen sink'. The actual preparations for camping started some weeks before leaving civilisation for the wide open spaces among the dunes. Stocks of tinned food and other suitable items would be built up in readiness; it was well known that appetites increased in the open air. Tents would be taken out of storage, inspected and repaired as necessary. Ropes would be examined and renewed while wooden pegs would be cut and trimmed. All these would be put in a sack together with a mallet and the other tools which might be needed. On the great day the cart or wagon arrived at the house and loading-up would begin. First went the flooring boards, then the heavy tin trunks and boxes with the china and cooking utensils. Bedding followed and, if room in the tent permitted, a bed stand too. A folding table, bench and chairs, together with a piece of carpet for the floor were also requisite items. The large tin 'jack' was placed where it would be easily reached in order to fill up with water at the pump in Ton Kenfig before proceeding onto the sand dunes to set up camp. Any 'passengers' would be settled safely on the top of the load.

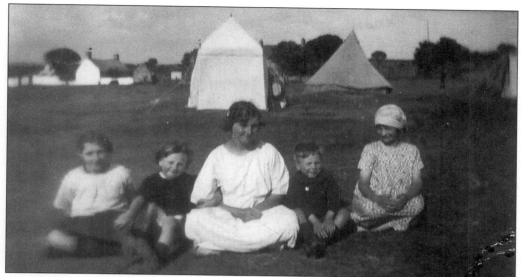

Camping on Kenfig green in the early 1920s, In the years between the two world wars, camping was 'the holiday'. People came from the Maesteg, Garw and Ogmore valleys, from Cardiff and Port Talbot, as well as from the Kenfig Hill area, to spend the summer months under canvas near the sea at Sker and Kenfig. In the 8 August 1913 issue of the *Glamorgan Gazette*, it was reported that: 'A great number of camps may be seen at Sker, chiefly tenanted by residents of Kenfig Hill'. After 1914, when charges were applied for camping at Sker, the sand dunes at Kenfig became the favourite site for campers. During the weeks before August bank holiday and on until the end of the month or even longer, the dunes at Kenfig, especially those from the Pool to the beach, were dotted with all sorts and sizes of tents, from 'lowly' bell tents to imposing marquees.

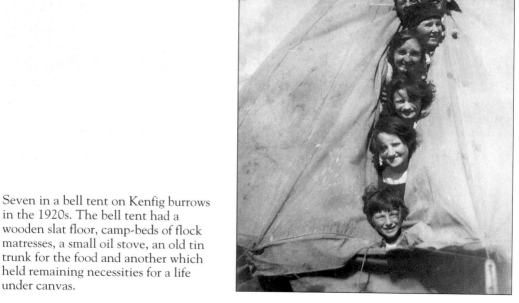

Seven in a bell tent on Kenfig burrows in the 1920s. The bell tent had a wooden slat floor, camp-beds of flock matresses, a small oil stove, an old tin trunk for the food and another which held remaining necessities for a life under canvas.

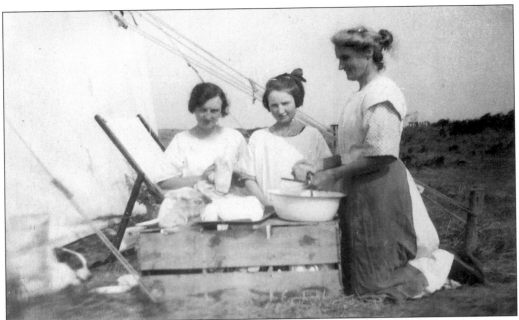

Washing-up time in camp. It was 'all hands to the sink' when camping at Kenfig in the 1920s. There was never any shortage of water. In addition to the supplies obtained from the pump at Ton Kenfig, wells were dug along the water course from the Pool, thus providing a good supply of crystal-clear water.

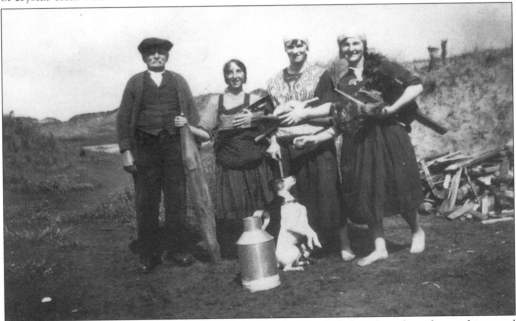

Collecting drift-wood for the camp fire at Kenfig in the 1920s. A fire place for cooking and boiling water was built outside the tent from an old iron grate and large pebbles. Regular trips to the beach provided all the fuel that was needed to feed the fire. As well as the camp fire, a small oil stove would be available for use inside the tent, especially for when it rained.

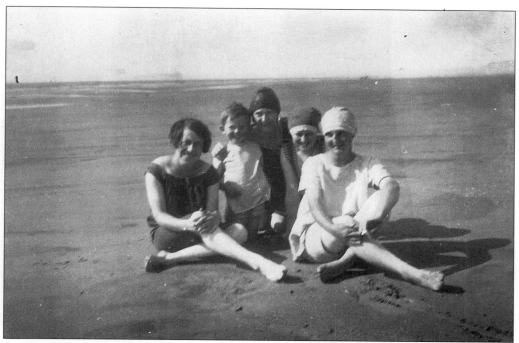

On the beach at Sker in 1920; not a pebble in sight.

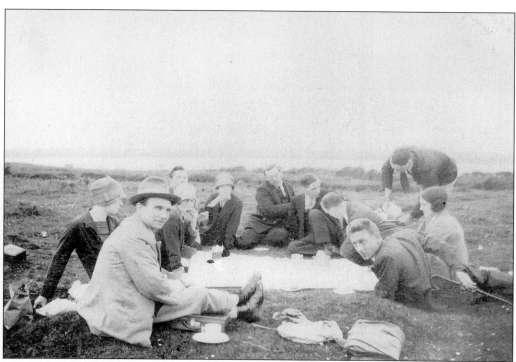

Always a favourite pastime – picnicking at Kenfig Pool in 1927.

Mrs Janet Davies, 'bando' player extraordinaire, April 1990. The bando stick that Janet is holding is over a hundred years old and belonged to her grandfather, Mr David Rees, who was a member of the famous Margam Bando Boys team. During the eighteenth and nineteenth centuries, the local people of Kenfig and district took part in a very strenuous pastime called 'bando' or 'bandy'. The name was derived from the curved ash sticks or bandies that were used to strike the ball in a game that is perhaps best described as a crude kind of hockey. The balls were of stuffed leather and usually made by local shoemakers. The playing of bando took place on Kenfig sands with the pitch extending a distance of two miles, from the one goal situated at the mouth of the River Kenfig to the other at Sker Rocks. Matches between rival teams of up to thirty players on each side were fast and furious and often lasted for hours. In its heyday, there was great support for the game. It is reported that on one occasion – 31 March 1817 – three thousand people turned out to watch a match between Margam and Newton-Nottage which was won by Margam. The publicans of the Angel and Prince of Wales inns at Kenfig certainly 'made hay that day' as they catered for the thirsty spectators by carting barrels of ale down to the beaches. The Margam team was celebrated in *The Margam Bando Boys*, a song written by Thomas Bleddyn Jones of Aberavon in 1859. This was also the year in which the Margam Volunteer Rifle Corps was formed. All the Margam Bando Boys followed their team captain, Theodore Talbot, into the Volunteers probably explaining why the badge design of this organisation incorporates two crossed bandies. Bando was to remain a popular sport in the area until the 1870s when it declined in favour of rugby football.